# How to Land a Movie Deal from a Book Nobody's Read.

Copyright © 2016 Kevin Richard Given all rights reserved

ISBN-13: 978-1540647948

ISBN-10: 1540647943

# Books by Kevin Given:

1) Last Rites: The Return of Sebastian Vasilis: Book 1 in the Karl Vincent Vampire Hunter series

2) Foul Blood: Book 2 in the Karl Vincent Vampire Hunter Series

3) Karl Vincent's Vampire Trivia Quiz Book

4) The Great Science Fiction Trivia Quiz Book

5) Lose Weight Feel Great

6) Kevin Given's Comic Book Reviews

7) Absent Friends: Elvis Presley

8) Absent Friends: Paul Newman

All of Kevin Given's books are available on line through amazon and Kindle. Comic books are available on Indyplanet and Kindle.

Contents

|   | About the author | 1 |
|---|---|---|
| 1) | Right town; wrong time | 2 |
| 2) | The Deal is Made | 7 |
| 3) | Female antagonists | 15 |
| 4) | The Protagonists | 21 |
| 5) | A Sneak Peek at the Novel | 55 |
| 6) | More Production photos | 91 |

# About the Author:

Kevin Given attended The University of Maine System, Presque Isle/Orono sites as a Speech/Communications major and graduated from the New *England School of Communications*. He has studied with the *Longridge Writer's Group* and *Writer's Boot Camp*.

Kevin has been a radio announcer since he was fourteen years old when he started working at the local college radio station. From there he moved on to his hometown radio station of WHOU radio, Houlton, Maine. Kevin has been a DJ in Maine, Pennsylvania, Ohio, Florida and California.

Kevin's most popular radio show was *Legends of Rock* which he produced and hosted during 2003 – 2007. The show profiled classic rock stars and was broadcast on the American Radio Network where it was heard worldwide on the web through KCLA-FM.com.

Kevin wrote a book about his personal struggles with weight loss and how he lost over sixty pounds with the help of a personal trainer called *Lose Weight, Feel Great*. He became a personal trainer to help others do the same through The Private Trainers Association (www.propta.com).

Kevin has turned his love for movies into the *Absent Friends* series of books, which looks at the film careers of movie icons that have passed on such as Paul Newman and Elvis Presley.

Kevin is also an avid Science Fiction fan and wrote his first trivia book on Sci-Fi called *The Great Science Fiction Trivia Quiz Book*. All of Kevin's books are available on line.

Kevin reviews comic books and has his own column which appears on the *Comics for sinner's* website.

Kevin started his own book franchise: *Karl Vincent: Vampire Hunter* which features two novels so far *Last Rites: The Return of Sebastian Vasilis* and *Foul Blood*. *Last Rites* is being turned into a major motion picture through *Crisp Film Works* and there is a 6 issue limited comic book series. You can find all of Kevin's books on line and through Kindle, comics are on Indyplanet.

# 1

This is the city. Los Angeles California. Some folks live here; some folks commute here. Other's fly out with delusions of grandeur to become movie stars. I was the latter. My names Given, I carry a script. Dum de dum dum. Dum de dum dum...dum!

So here I am in L.A., back in 2009. It's 3am and I cannot sleep. I've seen everything I could want to see on Netflix so I wander over to YouTube. I'm looking for a movie that will help cure my insomnia. Scrolling, scrolling on. Then, an obscure little number comes up. An old Don Knott's film from 1966 called *The Ghost and Mr. Chicken*. I almost scrolled right by it, but something kept me glued.

The actor who would become Mr. Furley on Televisions *Three's Company* years from this release date starred in this little Opus. However, in 1966 he is still in his prime, having played the loveable Barney Fife on *The Andy Griffith Show* for 5 seasons, earning 5 Emmy's for his portrayal of the Deputy to Sherriff Andy Taylor. It was the number 6 show per the Nielson ratings for that year. (1)

Knott's was at his professional peak. He had left the Andy Griffith show after the success of his film *The Incredible Mr. Limpet* led to a multiple movie deal with Universal, which included this quirky comedy. Ironically, it was an episode of his hit series that led to the plot of this film. The episode of *Andy Griffith's show* that would inspire this film was called *Haunted House* and aired for the first time in October of 1963. (2)

**From the IMDB synopsis:** When Opie and his friend Arnold accidentally send a baseball crashing through the window of an old abandoned house, they're too afraid to go in and retrieve it. The house has a reputation for being haunted but Barney admonishes Andy for not making the boys retrieve the ball anyways. The cowardly Deputy balks however when Andy

suggests that he get it for them. Even Otis the town drunk suggests that they stay away from the place. Soon, Andy and Barney - with Gomer in tow - are in the place. They hear strange sounds, see a painting with eyes that seem to follow you across the room and find a secret chamber. There's an earthly explanation to everything however. *Written by garykmcd* (3)

I'm getting a few chuckles from the film. About what I expected from the reliable Barney Fife from his peak era on the Andy Griffith show. Something amusing to fall asleep to. I'm like that Billy Joel song *Sleeping with the Television on*. I just can't sleep unless I'm watching TV (or my computer.) And then I start to doze off.

At this time in my life, I knew I wanted to become a writer. It had been a lifelong dream of mine and I was throwing about a few ideas. One was a Western called *The Village Priest* (working title) another was a Science Fiction idea which I hadn't even named. I had outlined both ideas and started work on the Science Fiction story but I wasn't feeling it. I would get a couple pages in then get restless, get up and leave my lap top. Never accomplishing much.

I did the same with the Western idea, I got a little further in that story as it had a more original and interesting idea behind it. It's based on a movie I saw back in the late '60's or early '70's a movie I can't even remember the name of. But one scene left a lasting impression with my young impressionable mind. The scene in question is where a bandit walks up to the village priest, who is in defiance of him, and slaps him across the face. Then he asks; "Well Padre, are you going to turn the other cheek?" The two-play stare down for the longest moment. You can tell the priest wants to haul off and deck the bandit, but he...turns the other cheek. The bandit just laughs.

I built the whole outline to my Western idea around that one scene. It has been gnawing at me since that night. I want to find the movie but I have no idea what it is. I caught it on late night Canadian Television (one of the fringe benefits of being brought up in Houlton Maine, on the Canadian border.) I would get in front of my lap top again. But I couldn't concentrate on writing. Everything that came out seemed clichéd and contrived.

In my zeal to write the grand story that would become the epic American novel I found myself unable to concentrate on any of the ideas I had so far. Until that night. I was in and out of sleep. Then Don Knotts walked into the House he considered haunted and the thought came to me *What if Don Knotts were a vampire hunter?*

I shot straight up, wide awake and set the movie on pause. I clicked on Microsoft Word and began a story outline and taking notes. I wanted to get this out while the idea was still fresh in my mind. I started another page and wrote a character outline for Karl Vincent and drew inspiration from the old Darren McGavin TV show *The Nightstalker*. I worked in elements of Roddy McDowell's *Fright Night* and threw in a dash of myself for good measure and, with the nervousness of Don Knotts, I knew the character would be a winner.

I studied with the *Long Ridge Writer's group* which was in Connecticut. They had a correspondence course which taught me how to create characters, story structure, plot development and the essentials of storytelling. It was while studying with them that I wrote my first *Karl Vincent: Vampire Hunter* story. I created Karl's arch nemesis Sebastian Vasilis. And I had Karl track Sebastian to an old potato barn in Island Falls, Maine.

I wanted to turn that story into a two-hour movie, but I couldn't sustain the suspense for a feature length film. That coupled with the fact that I really didn't know how to write a script made this endeavor difficult. I had to keep digging for a fresh idea worthy of my new iconic character. I hadn't yet studied the art of screenwriting at *Writer's Boot Camp*.

I wanted to write a script. But didn't know what to write about or how. So, I went to a local cinematic event; an *Evening with Akira Kurosowa* at *The American Cinematheque* where the famous director was a special guest. not only because I love his work but because I wanted inspiration from one of the greatest. There was a screening of his foremost movies with a discussion panel afterwards. (5)

During the discussion, it came up that there was always a film with the same theme of his classic *Seven Samurai* coming out every couple of years. The first one was the Western *The*

*Magnificent Seven* after that came many more including *Star Wars* and *Battle Beyond the Stars*. Even animated films and war movies like *A Bugs Life* and *Force Ten from Navarone* The theme was used in many genres…Wait a minute…That's it! The theme had never, to my knowledge, been used in a horror or horror/comedy film.

As soon as I left the show I bought the movies *Seven Samurai* and the American Remake *Magnificent Seven*. I got a notebook and watched both movies back to back and outlined both. I was about a week away from my first class at *Writers Boot Camp* but I was too anxious with my idea so, even before my first class, I used the outlines I had done for those movies to outline *Last Rites: The Return of Sebastian Vasilis*. I then thought of what I wanted my magnificent seven characters to be. I knew I wanted one of the vampire hunters to be a vampire. I also wanted an old man and a little girl.

I got the idea to use a dead President from the movie *Bubba Ho-Tep* which had Bruce Campbell in the dual role as Elvis Presley and an Elvis Impersonator, also Ossie Davis as a mental patient that thought he was JFK. That's when the old man/vampire became President Lyndon Johnson and the little girl became Athena Timon. I'll talk more about these characters later.

I completed my first draft before I started class and was so proud! I thought I'd created my masterpiece. The selling point would be *Fearless Vampire Killers* meets *Magnificent Seven*. This is perfect. It won't need another draft. I'll sell this before the first week of classes is over! *Yeah right*.

I had a lot to learn. No screenplay is ready after its first draft. I started class and everyone in the room liked the story. But there was a lot still wrong with it. The instructor would show what was working (in all our scripts) and what wasn't. But he said that my script was one of the better first drafts he'd seen. And he laughed a lot as we took turns reading our scripts out loud in the class. I knew he liked it.

As soon as the script was complete to everyone's liking I uploaded it to the Writer's Guild of America and had it trademarked and copyrighted. No one was going to steal the

masterpiece I had produced. My zeal exceeded my talent in those days, that's for sure.

In the end, it took three drafts to bring my meager offering up to masterpiece status. I was working as a Security Guard at the time which gave me plenty of time to turn it into a novel. Which I did. I got lucky that I could finish it. A little thing called the recession caused me to lose work and I would have to leave L.A. before I could sell my masterpiece. I went through a major depression. I had to leave Los Angeles.

The last thing I did in the few days I had left in Los Angeles was to upload my script to *The Black List*, which is a site that screen writers go to and hope that someone in the industry discovers their work. I had hoped that before I had to leave the great state of California that a miracle would happen and Sam Raimi would find it and contact me. I had written my opus with him in mind to produce/direct and Bruce Campbell to play Karl. But nothing like that happened and I wound up leaving L.A. A Major Depression set in. Did I come out here for nothing?

# 2

How can I sell scripts if I'm not in Los Angeles? A more pertinent question; how can I survive without a job? I returned to Florida for a minute and worked at one club until it shut down. In all five clubs in the area shut down putting several DJ's out of work so no one was hiring at that time.

I did what I dreaded to do. At the age of 49 I moved back into my Mother's house up in Lemont Furnace PA, about an hour outside of Pittsburgh. It was 2010. The first job I managed to get was DJ'ing weddings with *Exceptional Entertainment* out of Greensburg. After wedding season was over I got some employment at Long John Silvers (a very low point in my banal existence.) then I moved on to Sales person at Sears and I also worked as the custodian at a local movie theatre (at least I got to watch my movies for free lol.)

Then I got a break! A job that would pay me more than ten bucks an hour. The main club in Pittsburgh put me on as a relief DJ. Which is when I did something no writer should do. I got comfortable. While I was barely making ends meet I was still writing screenplays. My friend in Los Angeles had commissioned me to write several scripts for him and that kept me going along with the minimum wage and less than 20 hour a week jobs I was getting.

I wasn't writing but that doesn't mean that the creative juices weren't flowing. In the back of my mind I was creating the characters for what would become the second novel in the series *Foul Blood*. I had formed the character of Trevor Jackson. Karl's first partner. He was African American and the godfather to three of Karl's kids.

It was at this time that I was turning my script for *Last Rites: The Return of Sebastian Vasilis* into a 6 issue limited comic book series with artist Scott Story, whom I'd found on Facebook. So

even though I wasn't writing per-se I was still actively trying to get my Karl Vincent character noticed. It was also about this time that I had an origin story for Karl formulating in the back of my mind.

I had to have an ending for the second novel that would pack a serious punch. It had to be so gut wrenching that it would propel Karl into the vampire hunting universe to the point of losing everything that he holds dear. And that ending came to me. But I still didn't sit down to write because I was comfortable. It stayed in the back of my head.

I still aspired to turn my script into a movie and I plowed on in any direction that I thought would bring that dream to fruition. I started taking classes with the *Pittsburgh Film Makers*. I took a speech class with Amy Hartman and we read the script and performed it in the class. We had planned to do the whole thing on tape and then I could produce an animated trailer with that material but it never happened. I should have saved the bits and pieces that we had taped, but I never did. As they say hind sight is 20/20.

Foul Blood came back into my head about this time. I had different plans for the Trevor Jackson character which necessitated my creating another partner for Karl. Enter Lyle Chauncey. Lyle is young good looking and, at 26, one of the youngest officers in the Boston Police Department to make detective.

I also took a Meissner acting class while I was attending the school, again with Ms. Hartman. I was hoping to find actors that were interested in producing the film with me. Again we acted out scenes from the script and everyone said it was a good story. But those students also had their goals and agendas that were important to them, so, again nothing came of that.

At this time, I had discovered the *Douglas Education Center*. It was a school about a half hour outside of Pittsburgh. They had a table at Pittsburgh Comicon and were showing off all the special make-up FX they had created for different horror films. I was getting excited again.

I showed several of the comic books to the Dean of Admissions along with the script. I was in discussions to produce the film as a

class project. I attended the orientation and was impressed with what I had seen. They showed some student films and trailers to films that they had produced.

They had a tiny model of Stonehenge and they showed how they could put actors at Stonehenge without being there. The model was crude and before they showed us the practical effect I thought to myself "That's not going to look real" But when they were done I was blown away! It looked spectacular. I got the idea that we could film the resurrection of Lilith and set it at Stonehenge with their model.

Before I go on I want to let everyone know that this isn't just a two-bit school. *The Douglas Education* Center has an impressive resume and their students find legitimate work in the film making business.

**From the Douglas Education Center Website on Tom Savini's Special Make-up and effects class**: Perhaps there is no program in the world more defined by the people inside it, or by the spirit, energy, and imagination that they embody. Take your imagination where it's never gone before! Join the thousands of students from all over the world who have embarked on the journey that is... Tom Savini's Special Make-Up Effects Program. You always knew you were different. And you're finally listening to the little voice inside of you – the voice of creative reason. Now let us help you hone your skills as we teach you how to bring your drawings to life and nightmares to reality. This is *your* life. This is *your* dream. OWN IT. (5)

Who is Tom Savini? Anyone who knows anything about make-up and special effects doesn't need to ask that question, but, for those who are not familiar with this make-up expert let me fill you in:

**From Wikipedia: Thomas Vincent "Tom" Savini** (born November 3, 1946) is an American actor, stuntman, director, and award-winning special make-up effects creator. He is known for his makeup and special effects work on many films directed by George A. Romero, including *Martin*, *Dawn of the Dead*, *Day of the Dead*, *Creepshow* and *Monkey Shines*; he also created the special effects and makeup for many cult classics like *Friday the*

*13th* (parts I and IV), *Maniac, The Burning, The Prowler* and *The Texas Chainsaw Massacre 2*.

Savini directed *Night of the Living Dead*, the 1990 remake of Romero's 1968 *Night of the Living Dead*; his other directing work include three episodes of the TV show *Tales from the Darkside* and one segment in *The Theatre Bizarre*. As an actor and stuntman, he has appeared in films such as *Martin, Dawn of the Dead, Knightriders, From Dusk till Dawn, Planet Terror, Machete, Django Unchained* and *Machete Kills*. (5)

That's why I wanted to attend this school in Pennsylvania. I knew the special make-up effects students would create some bad ass vampires. And looking at the student made films we would be able to create a masterpiece! I was psyched. I would finally get this project off the ground. I showed the script and comics to several students and they wanted to make my masterpiece. Good to go. Let's start class. Not so fast.

The production class I needed to take was on Tuesday nights. Tuesday was my best shift at work. I would have to take Tuesday night off to take the class. I approached the other DJ's and asked if there was any way I could switch one of my night shifts so I could take the class. The answer was no. I was crushed. I couldn't afford to quit and there was no other job I could find that would match that money. I was about to give up on my dream.

After that let down I went back to concentrating on *Foul Blood*. Even though this story was going to be different from *Last Rites*, I still wanted a lot of humor in it too. Whereas *Last Rites* was an epic adventure that swept several exotic locales and I had that script in mind for a major motion picture, *Foul Blood* read more like the old noir novels from Raymond Chandler, Dashiell Hammet and Mickey Spillane. It all took place in Boston and there's only one vampire instead of thousands like *Last Rites*. I was thinking more on the lines of a television pilot for this story.

I wanted flamboyant suspects for Karl to interrogate. But what kind of suspects would they be. Something that would generate humor but keep the setting in a noir style. It was Halloween and I was in a club showing videos. Then a music video came on from a movie I'd seen dozens of times. It was *Time Warp* from the *Rocky*

*Horror Picture Show*. That's it! One of the suspects would be a cross dresser ala Tim Curry's Dr. Frankenfurter. And I thought further and decided to create a whole slew of Cross dressers for suspects. I came up with Betty Ford, Olivia Dacoit and Linda Lane. This would be fun. I did some research and discovered *Jacques Cabaret* in Boston and created my cross-dressing club loosely modeled after it and called it *First Impressions*. That's where the crime scene would be in this novel.

Of course, gay rights issues had become big in American politics and I knew that certain people might misunderstand what I was doing and call me all sorts of names like homophobe and bigot and I didn't want that. I have nothing against anyone in that community. So I contacted Jacques and told them what I was doing and after I had a manuscript written and some comic book pages done I sent it off to them and they seemed positive about what I was doing. **For the record**: I did not write *Foul Blood* to be a mockery or an insult to anyone in the LGBT community. I simply thought that it would be a fun place for Karl to interrogate his suspects and witnesses and add levity to the story.

So, after arriving at two dead ends in my effort to see *Last Rites* made into a movie I started writing *Foul Blood,* right? Well, you'd think so. I came up with interesting characters, a good setting. A shock twist ending and I should have committed it to paper right then and there. But no, I was comfortable. I was making more than enough money to live on.

Then it happened. For reasons that I will not go into the club decided that it did not want me to be one of their DJ's anymore, so, after almost 3 years of employment, they let me go. I had just paid my taxes and had no money. I was jobless and broke. Another manic depression set in and I felt like dying. I couldn't find a job for the longest time.

It was during that time that I finally started to write again. I was so depressed that I didn't want to go on. The only thing that got me out of bed at that time was having to get this excellent story down on paper. My funds were depleting fast so I knew I had to work again soon.

I was more than half way through the novel when I finally landed a job. Part time, minimum wage, at McDonalds. Another low point in my banal existence. For the longest time, I was making only enough money to pay for gas and food so I wound up getting evicted from my apartment. After *they assured me* that I could still live there and, once I got back on my feet again, catch up on rent. Ain't life a bitch?

I might add here that I lost my job on my birthday, this led to the curse. The Curse being that every year for the next four years I would be fired from one job or another on my birthday. As of this writing I have just celebrated another birthday and I'm still employed (fingers crossed.)

So I wound up moving back into my mother's house again. It's been a topsy turvy life in the commonwealth of Pennsylvania and I was ready to return to the state that I call home: Florida. But then I got the opportunity to work at another club. Which I did. It was hard quitting such an excellent job as master Chef at Miccyd's (sarcasm) but I returned to the DJ business once again at another club. (I had just finished the first draft of *Foul Blood*, so you see God, or the fates, or Karma, or something positive was guiding me along.)

I tried once more to return to the *Douglas Education* Center as I felt the old creative juices flowing again and I knew I wanted to make my masterpiece but once again I couldn't get the right night off for that production class. I was frustrated. I wanted to make my movie and I was being thwarted at every turn. I had to learn that the powers that be did not want me to make my movie in Pennsylvania.

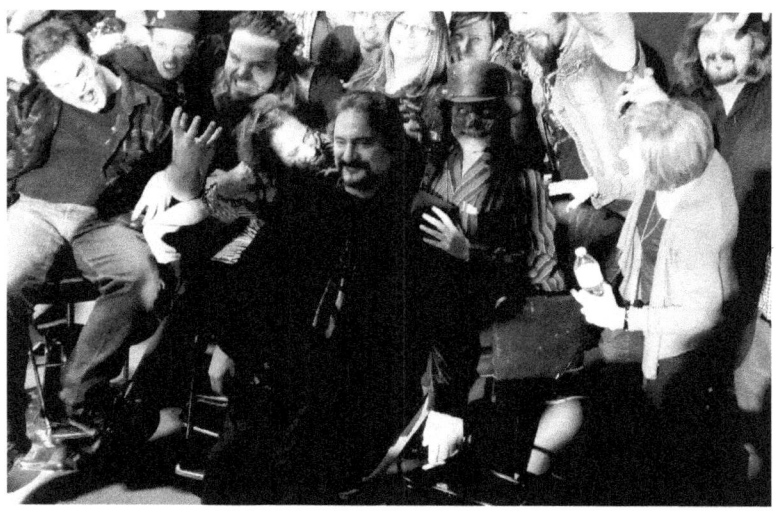

Tom Savini makeup artist extraordinaire with students and their creations.

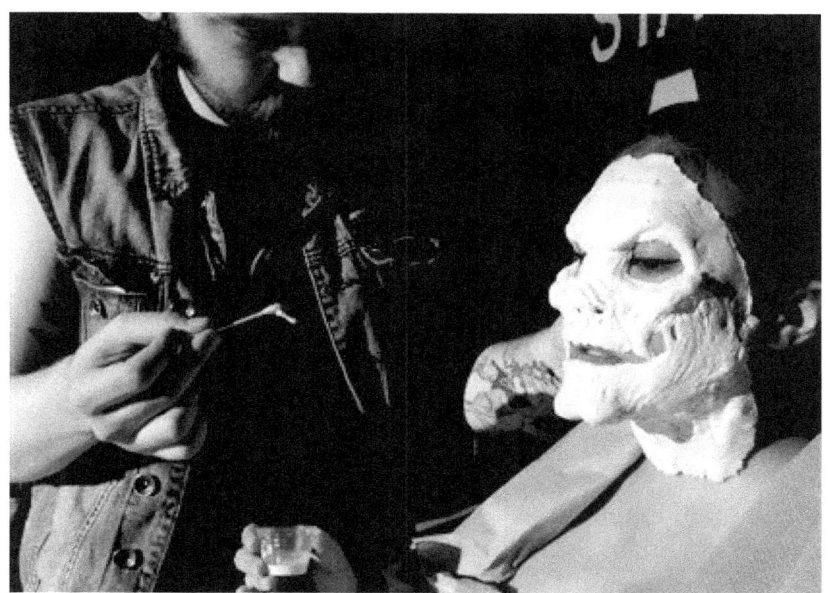

Becoming a vampire at Douglas Education Center.

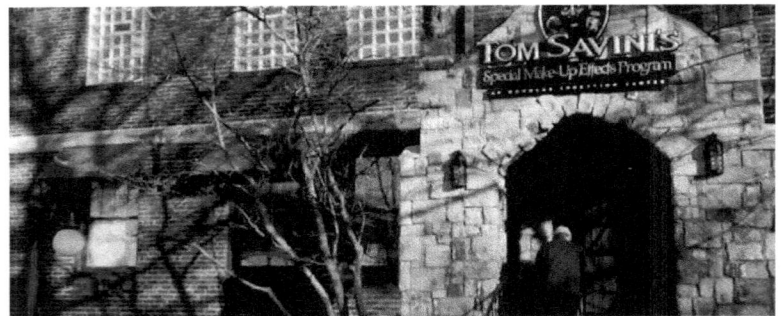

Where I originally wanted to make my movie.

One of the vampire victims.

# 3

The job situation was getting better again so I, feeling homesick, began calling clubs in Florida in hopes that some might be hiring. The money wasn't as good for me at this club as it had been at the other club and I was feeling incredibly home sick.

After a few months, I finally got the break I was looking for and returned to my adoptive home state of Florida. I say adoptive because I'm originally from Maine and, even though I love being from the Pine Tree State, I enjoy the weather a lot more in the Sunshine State.

I was so excited about returning to Florida I put in my notice and jumped on a train and headed south. As soon as I arrived my old friend Suzie Q picked me up from the bus station (we switched in Tampa from train to bus, for those who must know.) and I was home! I felt exhilarated. My old friend James once again allowed me to crash at his place as he always did when I would get the weird urge to leave and then realize that I belong in Florida and returned.

Just so the previous paragraph makes sense to you I originally left Florida for Los Angeles in early 2003 with delusions of grandeur to sell scripts. I wound up having to leave due to circumstances way beyond my control and I returned to Florida and again moved into James house. But always with the thought of returning to Los Angeles to learn how to sell scripts. It was in L.A. that I first produced and hosted my *Legends of Rock* radio show which aired on KCLAFM.com.

I became disillusioned with everything again and wanted to be in Los Angeles, not because I liked it better than Florida, L.A. is my second favorite place to live, but because I wanted to be where people learn to write and sell scripts. So a few years later I moved

back to the Golden State and this time I finally got to study with a group that knew how to write scripts that would sell in Hollywood. *Writer's Boot Camp*. (6)

After I completed the first class the recession had kicked in, and, even though I didn't lose my job, I found myself with not enough hours to make ends meet, let alone pay for the classes. I found myself with Willie Nelson *On the Road Again*. So, in just a few short years I bounced from Florida to Los Angeles back to Florida then off to Pennsylvania and one last time back in Florida again. Am I making you dizzy yet?

As you can well imagine I went through up and down periods where I would seem to get my act together and it would look like things were going in the right direction for me only to have circumstances dash my hopes and aspirations to the ground. But this time I knew I wanted to live in Florida for good and never leave again. And because of the constant discouragements that I faced in selling any scripts or getting my movie made I put it all on the back burner and just concentrated on getting good work again. No more trying to get this done anymore. I was aging and it seemed like no one would read my story or look at my script.

I got a good paying job, two, and I was happy to be home. I had an idea for a third Karl Vincent novel which would bring Karl face to face with Dracula himself. It was on the back burner and even though I was aching to write, the discouragement of the past 14 years was weighing heavily on me. I self-published the two Karl Vincent novels I had on Createspace but didn't know how to market them so they didn't sell at the time. I tried to put writing out of my head.... But I can't. It's what I do, it's who I am.

I had spent all those years trying to get a literary agent without really knowing the proper etiquette of approaching an agent. Which is why we all fail. The agents can see our amateurishness and will not even consider our work until we present ourselves professionally.

I took seminars and classes from people who don't give a sweet patotie if we succeed or not. They only want to take our money. None of their strategies worked (at least not for me.) and I had no clue which direction to go in.

So, here I am back in Florida, concentrating on getting work and not thinking about writing or selling scripts anymore. I just want to get things back together with a half decent job and get back on my feet again. Little did I know that karma, or the fates, or God, if you will, was just beginning to get the wheels in motion on my little opus.

It hadn't been a month upon my return to Florida that I got a good job thanks to my old friend DJ "Wild Bill" Fields and after that I got a call from Producer/Director Jeffrey Crisp. He was interested in producing my movie *Last Rites: The Return of Sebastian Vasilis*.

I was stunned. After all the effort I put into getting my masterpiece noticed with no success here was this guy calling me out of the blue who I didn't even know wanting to make my movie. I was excited and curious all at the same time. How did he even hear about my script?

Jeff told me that he found it on line. *How did he find it on line*? I thought for a long time and then I remembered *The Black List* (7). No, not the NBC TV series. It was the site that I had uploaded my script to a billion years ago (or 2010, to be exact) and had forgotten about.

So, After I had called a bunch of people trying to meet with Literary agents. writing letters and sending out about a thousand letters to all agents and agencies in L.A. and attending seminars until I was blue in the face to no avail. Here I was meeting with an actual Producer in the film making industry without even trying.

After all that hard work produced nothing here was someone who finally read the script. And the irony doesn't end there. I had only been back in the Tampa area of Florida for less than a month when Jeff called me *from Lakeland Florida*! I didn't need to leave Florida after all. All those years of hard work and here was someone calling me I didn't even know *after I stopped trying to sell it or get it noticed*.

I met with Jeffrey Crisp and we discussed my project. He read it and loved it and was looking for a project that would be his first feature as Producer with Preston Walden directing. Long story

short Preston couldn't do the project because of other commitments and Jeff would serve as Producer/director.

Jeff and I met several times to discuss what would be done. We went over casting choices and location shooting. He had other commitments obviously and I had to be patient but, eventually, the wheels were in motion and he cast this film. I couldn't be actively involved in the casting as I had to work 6 or 7 days a week to make ends meet. But I looked over each actor carefully and watched their demo reel on IMDB and was happy with Jeff's decisions.

Jeff went full force into pre-production and got all the paper work done as well as hiring the crew and pouring his own money into this project. I knew I had found someone who believed in this project as much as I did.

Finally, on May 31, 2015 we gathered the cast and crew together at the Polk theater in Lakeland Florida for the script read. My pulse was pounding as I read together for the first time out loud with this talented group the words I had put on paper more than five years ago, It was a major success and I knew we were about to produce the greatest vampire movie, ever! Mark my words here and now. We will beat *Twilight* at the box office!

In conclusion, my answer to the question "How do you get a movie deal from a book nobody's read?" Don't give up. Especially if you know you have something good. A lot of hard work. In the end, for me, none of that hard work seemed to matter, lol. It came down to luck. But don't take any avenue for granted. Get your work out there and, if it's good, someone will see it. It may not happen overnight. But it will happen!

For more information on the production of this film see my *Given to me columns* on the *Comics for Sinners* web site and the Facebook page: *Karl Vincent: Vampire Hunter*, please click "like" while you're there. After some time and the marketing expertise of Rob Kosberg (14) my book finally made the amazon best seller list. It made it to number six in the horror section and number one in mythology and folklore.

Several actors at the Polk theatre in Lakeland for the script read.
5/31/2015

The entire cast reading what will become the greatest vampire movie ever!

Actress Ashley Kroft is the Hebrew vampire/demigod Lilith.

# 4

## Lilith

Lilith is, in Jewish mythology, considered to be the first wife of Adam. She refused to be subordinate to Adam and was banished from the garden of Eden. That's when God made Eve. In Lilitu circles it is believed that Lilith is the one that gave Lucifer the idea to tempt Eve to eat the forbidden fruit. Her name is said to mean "Night Monster" or "Screech Owl" and people who follow her consider Isaiah 34:14 to be referencing her from the Bible.

In *"Last Rites: The Return of Sebastian Vasilis"* Lilith is one of three demi-gods whose resurrection Karl Vincent must prevent to stop vampires from taking over the earth. The other two are the Egyptian Sekhmet and the Hindu Kali. The opening scene in the story shows Lilith being resurrected before Karl is even recruited for this mission.

Because the vampires always fail in their quest -which they try once every thousand years- this time Lilith agrees to marry the Egyptian vampire Ptah, whom she turned into a vampire 4,000 years ago. This union will unite the vampires and cease the hostilities which prevent them from succeeding. (9)

A very beautiful actress has been cast to play Lilith in *Last Rites: The Return of Sebastian Vasilis*. Her name is Ashley Kroft. Actor Christian Riviera has been cast to play Ptah. Lilith is resurrected in *Karl Vincent: Vampire Hunter* # 1. and Ptah first appears in issue 5. You can also read the novel *Last Rites: The Return of Sebastian Vasilis*.

Ashley Kroft

Actress Jasmine Yampierre is the Egyptian Demigod/vampire Sekhmet.

## Sekhmet

As I sit here and contemplate my latest chapter, the Movie *God's of Egypt* has opened across the country, it's getting negative reviews and not doing well at the Box Office as of this writing, but, just like with Lyndon Johnson (*I picked the right time to pull out my Johnson,*) another Idea that I incorporated into the script is already happening in cinema. To my knowledge, there hasn't been a major motion picture released that focuses on Egyptian deities as main characters (The closest came with Brandon Frazier's *Mummy* franchise) until now. To me, this is further proof that my movie *Last Rites: The Return of Sebastian Vasilis: Karl Vincent, Vampire Hunter* In production at the time of this writing from *Crisp Film Works* is scheduled to come out at just the right time. For more information on the production see the Facebook page and please "Like" it and the sister page *Last Rites: The Return of Sebastian Vasilis.*

One thing that I do know is when the film gets released we will have the 18 – 55 male demographics locked down because we have some very pretty actresses in this movie. The actress who is playing Sekhmet is Jasmine Yampierre and she currently resides in Tampa Florida. She has been featured in productions like *Real* (2015), *The Next Step* (2014) also the television series *the Middle* (2014).

Before we discuss Sekhmet's purpose in this movie, let's look at the mythology of Sekhmet:

### From Wikipedia:

In Egyptian mythology, Sekhmet /ˈsɛkˌmɛt/[1] or Sachmis (/ˈsækmɪs/; also spelled Sakhmet, Sekhet, or Sakhet, among other spellings) was originally the warrior goddess as well as goddess of healing for Upper Egypt, when the kingdom of Egypt was divided. She is depicted as a lioness, the fiercest hunter known to the Egyptians. It was said that her breath formed the desert. She was the protector of the pharaohs and led them in warfare. (10)

Sekhmet also is a Solar deity, sometimes called the daughter of the sun god Ra and often associated with the goddesses Hathor and

Bast. She bears the Solar disk and the uraeus which associates her with Wadjet and royalty. With these associations she can be construed as being a divine arbiter of the goddess Ma'at (Justice, or Order) in the Judgment Hall of Osiris, associating her with the Wadjet (later the Eye of Ra), and connecting her with Tefnut as well.

In a myth about the end of Ra's rule on the earth, Ra sends Hathor or Sekhmet to destroy mortals who conspired against him. In the myth, Sekhmet's blood-lust was not quelled at the end of battle and led to her destroying almost all of humanity, so Ra poured out beer dyed with red ochre or hematite so that it resembled blood. Mistaking the beer for blood, she became so drunk that she gave up the slaughter and returned peacefully to Ra.[3] The same myth was also described in the prognosis texts of the Calendar of Lucky and Unlucky Days of papyrus Cairo 86637, where the actions of Sekhmet, Horus, Ra and Wadjet were connected to the eclipsing binary Algol.

In the Karl Vincent Universe, Setite vampires (which include the followers of Sekhmet) succumb to sunlight quicker than other vampires because of Set's falling out with the Sun god Ra. It should be noted that in the original manuscript for the movie the Egyptian deity was going to be Set. But that would have left us with two females and one male. It was the first artist on the *Karl Vincent: Vampire Hunter* comic book, Gil Murillo, that suggested Sekhmet because of her blood lust in Egyptian Mythology. This change gave our heroes an evil female trinity to confront.

The ghost of Sebastian Vasilis, Karl Vincent's arch nemesis arrives in Karl's office to recruit him on a deadly mission. He, along with 6 other vampire hunters, must prevent the resurrection of the deadliest vampire's known to mankind; the Hebrew Lilith, the Egyptian Sekhmet and the Hindu Kali. However, Lilith has already been resurrected! Actor Luis Antonio Howard will play Sebastian and I will play my own character of Karl Vincent.

The prolog to this film features the Resurrection of Lilith who will be played by actress *Ashley Kroft*. The ceremony begins as about 20 vampires have gathered in an underground tomb. The High Priestess Palti begins the incantation which will bring Lilith back to life. I have researched actual Lilitu ceremonies for our film

and the incantation used in the film is the same as ones used by followers of Lilith. Actress Michelle Yeager will play the high priestess Palti.

The resurrection of Lilith sets off a chain of events that will lead to vampires dominating the earth. If they succeed they will no longer have weaknesses such as crosses, garlic and sunlight.

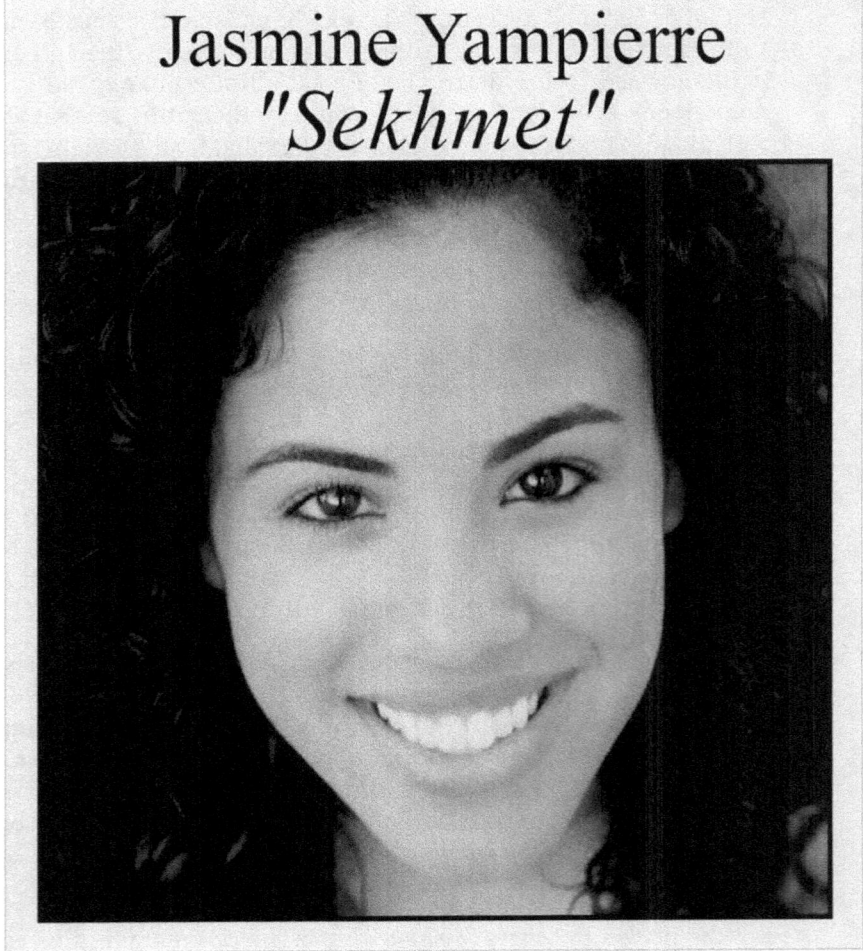

Actress Jasmine Yampierre

## Kali

Karl and his rag tag group of vampire hunters race off to Cairo, Egypt to destroy Lilith and prevent the resurrection of Sekhmet. Without giving away any plot points our heroes fail in this endeavor and Lilith, along with Sekhmet, fly off to Calcutta, India, for the ceremony that will resurrect Kali.

As we talked about recently, actress Jasmine Yampierre will portray Sekhmet. But who will play Kali? Ah! I'm not going to tell you the name of the actress playing Kali. She is a very young lady and a very special guest star. The actress in question will remain a secret for now, but trust me, casting director Jeffrey Crisp has gone all out to cast this vitally important role. You are in for a great surprise and a cinematic treat when you discover who is going to play Kali in this feature film.

*Who is Lilith in mythology?*

From the **University of Dayton** home page: Lilith

The earliest account of these creatures of the night derives from Mesopotamia. Lamatsu was a serpent demon who reportedly stole children from their homes and devoured them. Lamatsu was also responsible for infants who were found dead in their cradles. Another incarnation of Lamatsu appears later, in the guise of Lilith.

In early Hebraic writings, Lilith took the form of a winged demon with the body of a woman with owl-like talons for feet. She was reported to be the first wife of Adam (before Eve was created). Lilith was formed of the same earth from which Adam was created, therefore she considered herself his equal. That being the case, Lilith refused to be submissive. She was subsequently banished from God's presence to the demon realm. Lilith's offspring were damned to become demons with Lilith taking the title of "Mother of Demons."

Followers of Lilith believe that the scripture Isaiah 34:14 is a reference to her: "The wild beasts of the desert shall also meet with the wild beasts of the island, and the satyr shall cry to his fellow; the screech owl also shall rest there, and find for herself a place of rest."

*Who is Sekhmet in Mythology?*

From **Lyn Gibson's web page**: Sekhmet – Egyptian Vampire QueenAccording to writings found in the tomb of Seti, Sekhmet was said to be the daughter of Ra, an ancient legend tells of the end of Ra's rule on earth. Ra sends Sekhmet to destroy all humans that had conspired against him. The legend states that Sekhmet's blood lust had not been sated by the end of the battle, her thirst drove her to nearly destroying humans. Ra poured out beer laced with red ochre so that it would appear as blood. Sekhmet drank the laced beer and became so drunk that she abandoned her murderous spree peacefully and returned to Ra. After this Ra would refer to her as "The one who comes in peace" naming a holiday in her honor, "The Festival of intoxication". Sekhmet would now also be known as the protector of the undead, a ruler of the underworld.

*And finally, who is Kali in mythology?*

From **the Ancient History Encyclopedia:**

Kali's name derives from the Sanskrit meaning 'she who is black' or 'she who is death', but she is also known as Chaturbhuja Kali, Chinnamastā, or Kashia. As an embodiment of time Kali devours all things, she is irresistibly attractive to mortals and gods, and can also represent (particularly in later traditions) the benevolence of a mother goddess. Kali's name derives from the Sanskrit meaning 'she who is black' or 'she who is death'. (12)

The goddess is particularly worshipped in eastern and southern India and specifically in Assam, Kerala, Kashmir, Bengal, – where she is now worshipped in the yearly festival of Kali Puja held on the night of a new moon – and in the Kalighat Temple in the city of Calcutta.

# 5

### President Lyndon Johnson

*Q) What do actors Woody Harrelson, Bryan Cranston and David Raizor have in common?*

*A) They're all playing President Lyndon Johnson in 2016!*

What does that have to do with comic books? David Raizor is playing LBJ as a vampire in the movie adaptation of *Karl Vincent: Vampire Hunter*. # 1-6, which is an adaptation of the novel *Last Rites: The Return of Sebastian Vasilis*. Jeffrey Crisp, producer/director.

When I discovered that there were two more films coming out this year that featured LBJ as a character I was ecstatic! We are bound to get mentioned in most media blogs as the actors will be compared to each other and the real President. The idea to use a dead President came to me after I saw Don Coscarelli's low budget offering *Bubba Ho Tep*. It features Bruce Campbell as Elvis Presley and Ossie Davis as a mental patient that thinks he's JFK.

But there's more to the reason why I'm so excited about this development. You see the original President vampire was going to be Ronald Reagan. But Reagan wasn't working in the story. I had to change Presidents. So, after researching all the recently (within the last 50 years) deceased commanders-in-chief I finally decided on LBJ. You see, this is just one of many developments that tells me that everything is falling together in just the right way. It is no accident that production has begun now. It is karma, fate, the muses have spoken and it is God's will!

For those who don't know, Woody Harrelson is playing LBJ in Rob Reiner's bio-pic. Rob Reiner may seem like a strange pick to do a bio-pic on LBJ since he played the liberal anti-war Mike Stivic on *All in the Family* but this is what he had to say on the subject: "During the '60s, I was a hippy, and Lyndon Johnson was my president, at the time LBJ was the target of most of my generation's anti-Vietnam War anger. But as time has passed and my understanding of political realities has grown, I've come to see LBJ in a very different light. He was a complex man, a

combination of brilliant political instinct, raw strength, ambition and deep insecurities." (8)

Bryan Cranston is playing the character in HBO's *All The Way*, which is a play on LBJ's campaign slogan *All the Way with LBJ*. I do not believe for a second that it is mere coincidence that all three films began production in 2015. It was meant to be. So you see, I picked the right time to pull out my Johnson! (13)

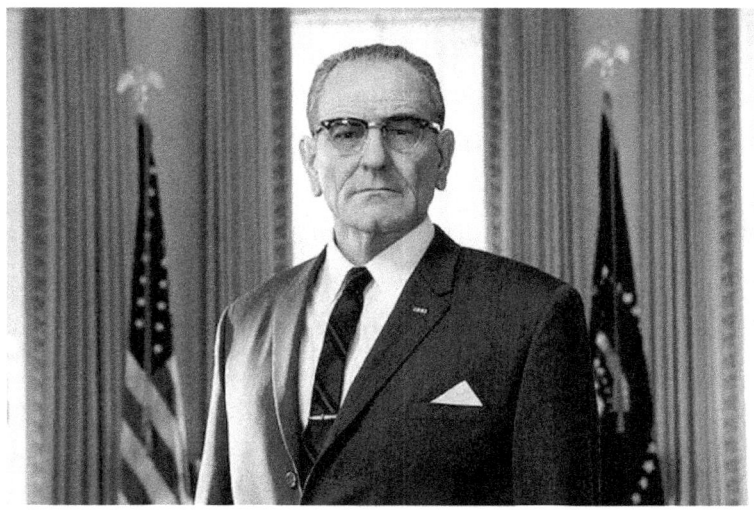

Bryan Cranston as Lyndon Johnson in the HBO production *LBJ all the Way*

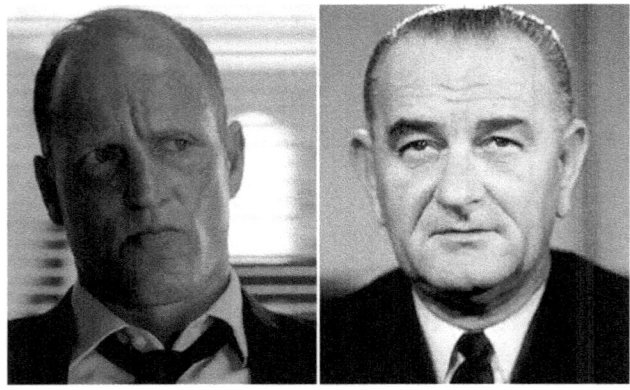

Woody Harrelson and the real LBJ

Woody Harrelson as LBJ.

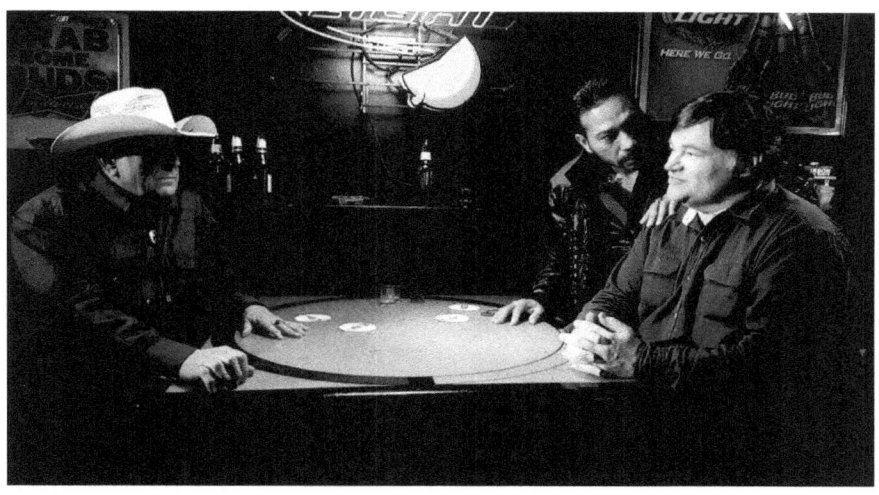

President Lyndon Johnson (David Raizor) Sebastian Vasilis (Luis Antonio Howard) and Karl Vincent (Kevin Given)

Sebastian Vasilis (Luis Antonio Howard) prepares Karl Vincent (Kevin Given) to meet President Lyndon Johnson.

Luis Antonio Howard as Sebastian Vasilis and David Raizor as LBJ on the set of *Last Rites: The Return of Sebastian Vasilis.*

President Lyndon Johnson (David Raizor) meets Karl Vincent (Kevin Given)

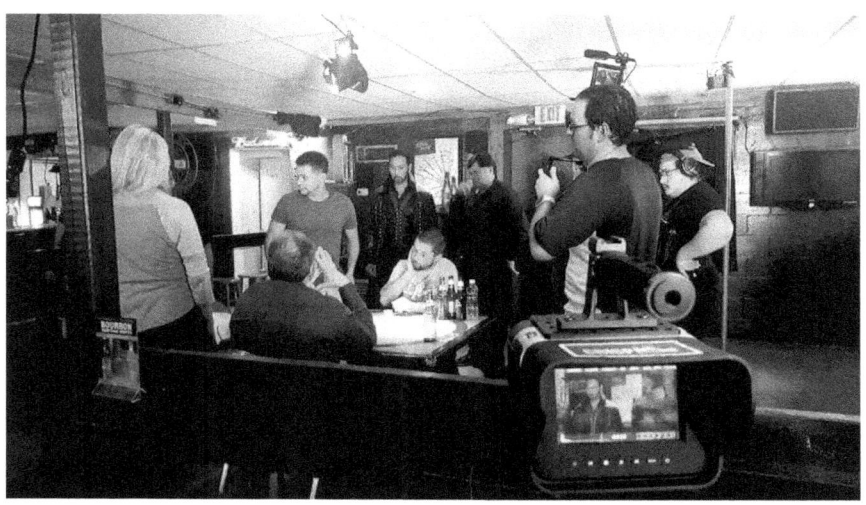

Quit on the set! Filming *Last Rites: The Return of Sebastian Vasilis.*

## Kate Bryant

Kate is one of the most complex characters in the story. You can read about her in the novel *Last Rites: The Return of Sebastian Vasilis*. also, the comic book *Files of Karl Vincent*. # 2. She first appears in *Karl Vincent: Vampire Hunter* # 3.

Kate is of mixed heritage. Her father was Gabriel Bryant, who was fascinated by Japanese culture. He married a Japanese woman, Satou Rina (now Rina Bryant) and moved to Japan to set up his own business. During the crash of '87, Black Monday, he lost his business, and, desperate for money, follows his brother-in-laws advice and starts working for a Yakuza gang.

When Kate was 8 years old she watched as her father was gunned down in cold blood. Her father's killer was Yoshi Isamu. Isamu accused her father, Gabriel Bryant of killing his brother, a Sumo Wrestler named Funaki. After her father's death, her uncle led her to a sensei named Mitsuaki, where she trained with revenge on her mind. Her one goal in life was to avenge her father's death. For twenty years, she had nothing else on her mind.

Sebastian leads Karl to Kate while she's tracking Isamu. After a difficult time, convincing her, she finally agrees to accompany Karl and the other vampire hunters on the mission to prevent vampires from taking over the earth.

Actress Jackie Pitts has been cast to play Kate in *Last Rites: The Return of Sebastian Vasilis*. She is very pretty and fits the ethnicity of her character as she is part Japanese and Caucasian. The cast of this movie is very diverse. We have just as many female protagonists and antagonists as male. It's a fun story and in production now. Visit the Facebook pages for *Karl Vincent Vampire Hunter* and *Last Rites: The Return of Sebastian Vasilis* for full information. From *Crisp Film Works*.

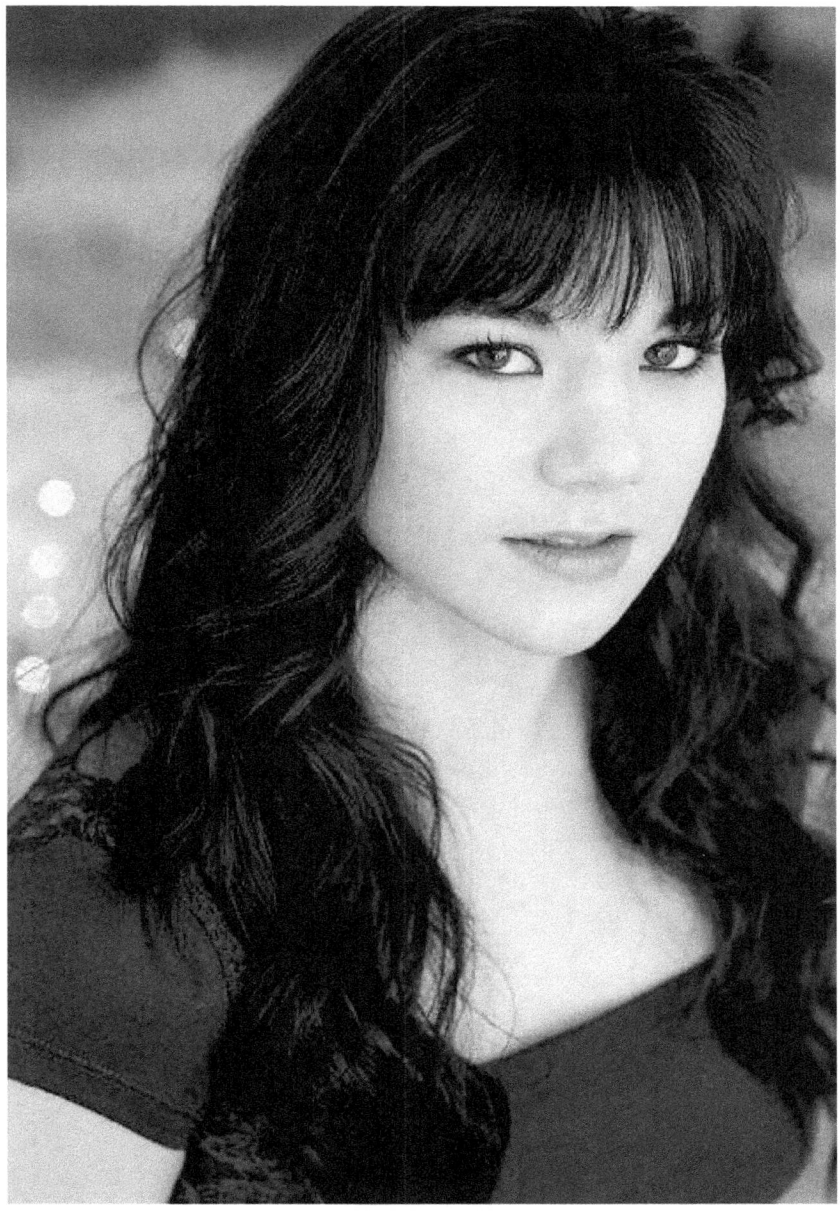

Actress Jackie Pitts is Kate Bryant.

After Kate witnesses her father gunned down in cold blood she's taken to meet her Sensei, Mitsuaki. From *Files of Karl Vincent* #2 Melissa Erwin art.

Kate confronts the man that killed her father more than 20 years ago, Yoshi Isamu. *From Karl Vincent: Vampire Hunter #3.*

I want to talk about the immortal first family: Athanasius (Nathan) Timon, his wife Rhea and their daughter Athena.

## Athena Timon

Athena Timon was born in 43 BC and raised in Rome. Her Parents are Athanasius Timon (known of as Nathan in the 20th and 21st century) and Rhea Timon (former wife of Cronus). When she was ten years old her mother led her to the Witch of Endor (Endori) to be trained in "Magic" and spells. When she turned 12, Emperor Augustus enlisted Endori's help in the battle of Actium, 31 B.C. while she was gone, her sister (Nocturi) oversaw training young Athena. Athena said to Endori "I didn't know you had a sister. She isn't mentioned in scripture."

One day when Athena was learning how to create a (Witches) brew. Nocturi asked her for certain ingredients and Athena handed her the wrong ones. The witch, upon drinking the special brew, thought it would empower her to become a stronger witch. Instead she was accidentally poisoned and died. When Endori arrived home about a month later. Athanasius instructed his daughter to tell her the truth. Upon learning that Athena was responsible for Nocturi's death she flew into a rage and put a curse on the 12 (14 in the movie) year old girl. A curse that said she would be stuck at the age of 12 (14) until she slayed Lilith, the first vampire, who, now was in a state of hibernation.

Athanasius and Rhea begged the witch to remove the curse, but Endori refused. When Karl Vincent arrived to recruit Athena 2000 years later, Athena would relate the story to him and add: "What you would call 'Magic' is simply the strength of will to bend the fabric of space and time. Mortals don't live long enough to develop this ability. Most immortals don't develop it because they do not have the patience for the thousand-year training program."

*Karl Vincent: Vampire Hunter; Last Rites: The Return of Sebastian Vasilis* Now in Production through *Crisp Film Works* Lakeland Florida. Buy the novel on Amazon, comics on Indyplanet (issue one free) both on Kindle.

Jaylin Byrne is Athena Timon.

Jered Allen is Athanasius (Nathan) Timon.

Jered Allen on the set.

### Athanasius (Nathan) Timon

I want to discuss Jered Allen, (see his IMDB page) who is playing Athanasius Timon, Athena's father. Athanasius Timon is the most important character in my literary universe. He will show up in every novel that I write. If I write a Western, he'll appear in it. If I write a Science Fiction, he will appear in it. He is the link to all my novels and characters. In *Last Rites* he joins Karl and his daughter with the other vampire hunters on this mission while they're in Cairo to recruit Thor.

I cannot wait to film the scene in Cairo where Karl and company first meet him since he is the most important character in the Karl Vincent universe!

Actor Guy Leinbach is the Greek god Thor

## The Greek god Thor

I want to discuss the character of *Thor* in the Karl Vincent universe. First, I know that Marvel's Thor is the definitive Thor in the world of comic books, but other comic book companies have a "Thor" in their mythology as well. So, I am obviously not going to do the same thing that they did with the character, having said that, here is Thor in the KRG universe:

## The Greek god Thor: A "special needs" immortal.

Thor was born in Ancient Greece in 3218 B.C. to the same clan of immortals as Athanasius (Nathan) Timon, his birth name was Herakleias and he was worshipped by the ancient Greeks as Herakles or in Roman: Hercules. After the disastrous marriage to Deianeira he travelled abroad, eventually settling in the Norway.

He was abandoned by his parents, who were Titans, so he does not know them. He was raised by Greek peasants whose names he does not remember because he was struck by lightning several times in life. The peasants who worshipped him reasoned that his father must be Zeus. He was first struck by lightning around his twentieth birthday.

When Hercules was trying to take his bride Deianeira home, he had to cross the Evenus River. Nessus, a centaur, served as ferryman. First, he rowed Hercules across and then, as he started to row Deianeira across, he tried to rape her. Hercules, justly enraged, drew one of his poisoned arrows and shot the centaur. Before he died, the centaur persuaded Deianeira to take some of his blood to use as a love potion should Hercules ever cause her to worry.

In time, Deianeira became suspicious of Hercules' interest in another woman, named Iole, so she smeared some of the carefully-saved centaur blood on a tunic and gave it to Hercules, trusting that it would act as a love potion and return him to her. Unfortunately, the centaur had lied. The blood contained not a love potion, but a powerful toxin from the poison with which Hercules had tipped his arrows. It had come from the Lernaean hydra that the hero had killed in his second labor. When Hercules put on the tunic, it burned his skin. He was in such

excruciating pain that he wanted to die. Note that the burning would have killed an ordinary human, but Hercules was not such a one. Legend says that after consulting an oracle for advice, he had a funeral pyre built for himself. He then mounted it and eventually persuaded a friend to light it. He was then allowed to die and went to the gods where he was reconciled with his tormenter, the queen of the gods, Hera. She allowed him to marry her daughter Hebe and live among the gods thereafter. That's the legend, but the reality is that Herakleias journeyed as far away from Greece as possible and wound up in the Norwegian area. He was still burning from the poison when Sif, an Asgardian Immortal, brought him to the goddess Idun, who gave him a golden apple of immortality, which cured him of the burning sensation. The Asgardian immortals "adopted" Herakleias.

He was from then on known of as Odin's son, not Zeus, and was given the name "Thor." The Norwegians dyed his hair red. After pagan worship ceased "Thor" wandered the globe and wound up in Egypt. Subsequent lightning strikes have left him as a "special needs" immortal and he often confuses the old days among the Olympian immortals and the Norse Immortals, calling himself the Greek god Thor. Thor was recruited by Karl Vincent on his mission to prevent the resurrection of Sekhmet and Kali and destroy Lilith, who was resurrected in *Karl Vincent: Vampire Hunter* #1.

Thor will be played by actor Guy Leinbach in *Last Rites: The Return of Sebastian Vasilis*. In production now from *Crisp Film Works*.

## From Wikipedia:

The earliest records of the Germanic peoples were recorded by the Romans, and in these works Thor is frequently referred to—via a process known as *interpretatio romana* (where characteristics perceived to be similar by Romans result in identification of a non-Roman god as a Roman deity)—as either the Roman god Jupiter (also known as *Jove*) or the Greco-Roman god Hercules.

The first clear example of this occurs in the Roman historian Tacitus's late first-century work *Germania*, where, writing about the religion of the Suebi (a confederation of Germanic peoples),

he comments that "among the gods Mercury is the one they principally worship. They regard it as a religious duty to offer to him, on fixed days, human as well as other sacrificial victims. Hercules and Mars, they appease by animal offerings of the permitted kind" and adds that a portion of the Suebi also venerate "Isis". In this instance, Tacitus refers to the god Odin as "Mercury", Thor as "Hercules", and the god Týr as "Mars", and the identity of the Isis of the Suebi has been debated. In Thor's case, the identification with the god Hercules is likely at least in part due to similarities between Thor's hammer and Hercules' club.[6] In his *Annals*, Tacitus again refers to the veneration of "Hercules" by the Germanic peoples; he records a wood beyond the river Weser (in what is now northwestern Germany) as dedicated to him.

In Germanic areas occupied by the Roman Empire, coins and votive objects dating from the 2nd and 3rd century AD have been found with Latin inscriptions referring to "Hercules", and so in reality, with varying levels of likelihood, refer to Thor by way of *interpretatio romana*.

Actress Anja Akstin is Stacy Hamilton.

## Stacy Hamilton

Stacy is one of the most normal characters in the Karl Vincent universe. She isn't a ninja warrior, an immortal or a vampire. In fact, she's an average girl in her mid-20's that works as a dental assistant in Karl Vincent's Office building. A young lady struggling to make a living and just get by. Think of Linda Hamilton's Sara Conner (*Terminator* – 1984,) an average waitress who's about to be thrust into the adventure of a life time. (Easter egg: I've included the name of every actor that's played Dracula on film, up until 2010 when I wrote the story, in the novel *Last Rites: The Return of Sebastian Vasilis*. Stacy's full name is Stacy Georgette Hamilton, after George Hamilton, who played Dracula in 1979's *Love at First Bite*.)

The most recent scene that we shot is the Motel room scene in Cairo. Karl knocks on Stacy's motel room door. Before I tell you what may (or may not) happen, let's discuss the background of Stacy and Karl's relationship. After Karl loses his detective job and his wife (Barbara) throws him out of the house, he winds up moving into an office building and setting up his own paranormal investigator business. He must call himself a paranormal investigator because you can't call yourself a vampire hunter in the good old U.S. of A. He can't even afford an apartment so he's living in the office building and working part time as a Security Guard.

Stacy is the dental assistant to Dr. Chris Lee (another Dracula actor) and when she learns what happened to Karl she initially thinks he's crazy...until Karl saves her from the vampire Abssi. When Stacy learns that Karl isn't crazy she begins to admire him, realizing that he has lost everything to protect the world and rid our fair planet of vampires. She develops a little crush on Karl and follows him on the dangerous mission to Cairo, Egypt.

It's in Cairo that she decides she wants to be with Karl and plans to seduce him. And now a drunken Karl Vincent has knocked on her door. Will Karl start dating a smoking hot blonde that's young enough to be his daughter, or will he stay faithful to his estranged wife Barbara? Can't wait to find out? Read the novel *Last Rites: The Return of Sebastian Vasilis* or the 6 issue limited series of

*Karl Vincent: Vampire Hunter* comic books (first issue free digitally on Indyplanet.) Novel's available on Amazon, comics on Indyplanet, both are on Kindle.

Anja Akstin close up. Stacy is preparing for Karl to come visit her in her Motel room.

Karl Vincent (Kevin Given) and Stacy Hamilton (Anja Akstin)
From the movie

Karl Vincent and Stacy Hamilton from *Karl Vincent: Vampire Hunter* #1 available free on Indyplanet.

Preparing to shoot the Motel room scene.

The beautiful Anja Akstin as Stacy Hamilton

Will Karl cheat on Barbara? Enquiring minds want to know.

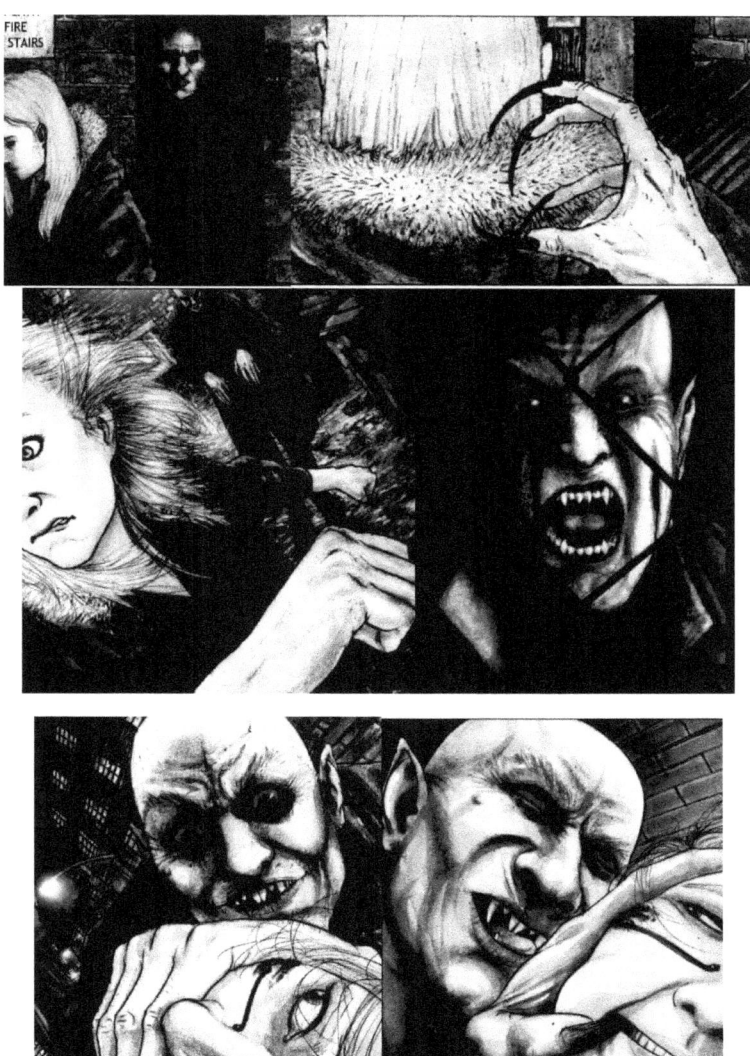

Stacy Hamilton under attack from the vampire Abssi. Gil Murillo art from *Karl Vincent Vampire Hunter #1* digital copy available free on Indyplanet.

A panel from *Karl Vincent: Vampire Hunter* #1 Stacy attacked by Abssi. Actress Anja Akstin in make-up for the scene.

Now let's take a sneak peek at the novel that started it all!

# Acknowledgments

I would like to take sole responsibility for the literary masterpiece that you hold in your hands, but, alas, I cannot take full credit.  Oh, the story is completely mine, but as a first time author I can tell you that writing a book is a lot more difficult than I thought it would be.  It took me six months to complete the first draft and I thought it was perfect...then I read it.  It needed much work so I set out to revise it myself, but I am not *Stephen King*, I am not *Ernest Hemingway*, heck I ain't even an English major.  But I have studied with "Long Ridge Writers Group" and "Writers Boot Camp" and had a fun horror/comedy story to tell.  So here I am three years later with a manuscript that I'm finally proud of (Yes my story pre-dates *"Abraham Lincoln: Vampire Hunter"* if anything inspired me to use Lyndon Johnson in this story it was the film *"Bubba Ho-Tep"* starring Bruce Campbell.)

I sought out help from several published authors and the best aid I got came from **Karen Victoria Smith, Richard Krawiec** and **David Bischoff.** Karen's best known work to date is the novel *"Dark Dealings,"* Richards best-known work is a novel called *"Time Sharing."* David was nominated for a Nebula award for his short story *"Tin Woodman"* which was adapted into an episode of *"Star Trek: The Next Generation."* He has written many novels and short stories.  His first novel was *"The Seeker"* which was published in 1976.  The thing that was interesting about David is that he also has a novel where Lyndon Johnson turned into a vampire (*At the Twilight's Last Gleaning*) so his help was invaluable. All three authors offer services as manuscript editors.

I would also like to thank the editorial staff at *"Createspace"* for diligent work and helping me smooth out some rough edges.

Then there's **James Hayes** of Pennsylvania who provided valuable information on Ninja warriors, thanks much for your input James. I would also like to thank artists **Gil Murillo** and **Scott Story.** Gil and Scott both worked on the *"Karl Vincent: Vampire Hunter"* comic book which issues 1-6 adapted this story (available on Indyplanet) they both provided suggestions which proved invaluable to this publication.  Thanks to everyone for helping to make this publication possible.

# Prequel

Being dead had its advantages. Johnny could control his sense of smell and didn't need to take in the putrid stink of dead fish and oil if he didn't want to. He could block it or enhance it. Something humans couldn't do. But Johnny didn't mind. He actually liked the scent.

A.D. Nineteen hundred and seventy-three, total darkness, Texas; the smell of Texas dirt and Texas dry leaked into the room. Johnny Carradine, or rather the creature that was once Johnny Carradine, opened his eyes. Johnny did every night in the darkness. It was time for him to arise, and as always, he had a purpose in mind.

"That bastard," he spat through cracked lips. The air that came out of his lungs was fetid and cold. Somewhere to the left of his coffin he heard scurrying and chitters. Rats? He sniffed. The place smelled of offal and old pee, but it didn't bother Johnny Carradine.

"The bastard's going to pay," he snarled.

He could taste old blood in his mouth. "Vengeance," he whispered. "I want my vengeance." He could almost taste new blood.

He was going to make the man pay. It was that damned bastard's fault he was like this. Johnny would kill the President of the United States of America. Richard Nixon?

Oh no, not Nixon. Not the current president, but his predecessor, the guy who was in office before Nixon. Even though he wasn't the guy, either, who was responsible for drafting Johnny when he was only eighteen and sent him to Vietnam. In 1960 his whole life was in front of him. He had been so scrawny he barely passed the physical examination, but they sent him to Nam anyways.

Now his life was over.

His sanity had eroded. He had been far too young to deal with what had happened to him.

After the war, he made his plan. He journeyed to Texas and found an old abandoned oil refinery. JFK wouldn't be the only president killed in The Lone Star state. Oh no. He was determined to see that his successor would also be destroyed, too.

But it really hadn't been Kennedy who had begun it. Johnny had been sent to Viet Nam under Eisenhower. And he went willingly. Oh yes, he deemed it his duty to serve his country. He did three tours of duty and was proud of his service, even when the goddamned hippies started their protests.

But he had turned during LBJ's administration. And that was the man that he blamed for his current affliction.

He didn't blame the creature that bit him and caused his affliction, that creature was just hungry. If Carradine hadn't been in Viet Nam then the parasite wouldn't have been able to feed on him. But that was 1963.

Now, ten years and thousands of miles away, on this cold January Texas night, Johnny lifted the lid and read, for the thousandth time, the obituary that was taped to the inside of his coffin.

The clipping erroneously reported that his platoon had been wiped out by the Viet Cong. The truth of the matter was that they had been wiped out by a clan of Setite Vampires. Most of the platoon had been killed, but several had turned, though he doubted that the vampires who caused his condition knew or even cared about that fact.

In his mind's eye, he imagined what it was like when the military personnel drove up to his mother's dooryard in their finest dress uniforms. The one on the passenger side would exit the vehicle with a grim look on his face holding official papers. His mother would already be in tears as she knew what the letter said before it was handed to her. It would be the notification of her son's death.

It would've been a cruel blow for Cindy Carradine, who had been widowed a year before her son left for Viet Nam. Johnny's father, Seth, had been killed while cutting trees in a freak chain saw accident. This would be two family tragedies a year apart.

Johnny had agonized again and again over whether he should go home and tell his mother the truth. Which is more devastating, to let her think that he was dead or to let her know that he had become one of the undead? Would the knowledge of his current existence be more painful to her than what she assumed was true? He didn't know. He needed help with this decision and he didn't know where to get it.

Johnny closed the newspaper on his obituary and turned it over to the front page. There was a different photo there.

It was LBJ. Johnny felt foam form in his mouth. His eyes narrowed and he was sure they had turned red with hatred. It didn't matter that LBJ had nothing to do with Johnny Carradine going to Viet Nam, or that he had volunteered for his last tour of duty, the tour that saw him turn into a Setite. Somehow it just seemed that it was all Johnson's fault! He ripped the picture out of the newspaper and carried it with him everywhere.

Now Johnny arose and tore the picture of Johnson off the inner lid to his coffin. He put it in his mouth and chewed it, then swallowed. Johnny wouldn't need it any more after tonight.

\*\*\*\*

The former President of the United States of America had let his hair grow long. He was depressed. During his last year in office, teenagers had taunted him on the White House grounds.

When he had taken office, after JFK's assassination, he had been incredibly popular. In 1964, he won the largest popular vote in the history of the nation; a full twenty-two percentage points over his opponent.

When he made his first speech to Congress as President he said the appropriate thing; "All I have I would gladly have given not to be here today."

Before he became the President, he was the Vice President and before that he was Speaker of the House, and one of the most effective Speakers in the history of this nation.

As President, he thought nothing would be able to stop him. He passed legislation for health care, revitalized a dead economy, and supported civil rights like no other before him had ever done, or after for that matter; the architect of the Great Society. That's what he thought history would say about him.

Yet he would not be remembered for any of this. What was he remembered for? Not something that he did. It was a brush-fire that he did not start, but rather inherited, much like the Presidency that he resided over for the first year of his administration. It was someone else's mess.

He was a good politician. He had known when it was over and had decided not to run for re-election once it all turned. Besides, he knew that he wouldn't be able to live with the idea of Bobby Kennedy beating him in the primaries. That was the real reason for his leaving the presidential race. Of course, the opposing party would now inherit the white house because of his fateful decision. That's the way it went.

Now it was Sunday, January 21st to be exact, when he was just sitting in his home, brooding about the collapse of his presidency. The air was crisp and the night sky clear, lit up with incredibly bright stars, brighter than usual. Ladybird called him out to the porch shortly after the sun had set. She wanted him to see an unusually bright shooting star that had appeared.

"Come out quick!" She yelled to the former president.

"What is it?"

"A shooting star," she said.

"Oh, we've seen plenty of them."

"Not like this one dear."

He ambled out of the house as fast as he could. He had taken up smoking again against his wife's wishes and had gained weight since his presidency. His drinking had also increased.

"That's real nice dear." He said to his wife as the shooting star disappeared into the horizon. The former President breathed in a dose of that healthy Texas night air, then sat down on the porch swing and lit a cigar. He buttoned the top button of his shirt and pulled his sweater shut. The temperature had dropped considerably in the last hour.

"Well, I think I'm going to turn in," Ladybird informed her husband. She brushed the cigar smoke away from her nose and said "Are you coming?"

"In a minute dear," he told her. "I'm gonna have another smoke."

Ladybird shook her head and turned to go inside. He sat, smoking, and watched as the inside lights went off. He pictured the way she'd climb into bed, sitting sideways, feet together, and then turning until she was flat on her back. While he was thinking of his wife, he heard a rustling sound and looked up to see a tall lanky man dressed in B.D.U. green cross the yard and step up to the porch.

"God damn it how did you get past security?" Lyndon asked with a confused look on his face.

"Those idiots at the front gate, it was easy," the stranger said and laughed.

"What the hell do you want?" Lyndon said as he crushed the cigar and tossed it into a garbage can.

"Dare I say it? It's a classic."

"Say what?"

"I want to suck your blood." The stranger spoke in a phony Hungarian accent.

"You'd better get your damn ass out of here, or I'll..."

"You'll do nothing, old man, except die."

Lyndon saw by the look in his eye that Johnny meant business. He was going to make his

mark on society.

The President saw Johnny's bloodshot eyes open wide and felt his head push back. He struggled surprisingly strong for a man his age. He grabbed at Johnny's neck and Johnny had to use his full strength to pull the man's hands off. He pulled LBJ to his feet and they stood on the porch in an awkward dance like embrace, each one trying to hold down the arms of the other. Finally, Johnny wrenched one arm free, yanked aside the former president's head, and sank his teeth deep into LBJ's jugular vein.

The former President struggled nobly but in the end he was no match for a being that had three times his strength. He succumbed to the vampire's bite and keeled over.

Lyndon was barely conscious but he could smell the demon's rancid breath as Johnny spoke, "now, Mr. President, I will prevent you from becoming what I am by decapitating you."

But shots rang out and Lyndon and Johnny snapped their heads in the direction of gun fire. Several secret service agents were running in their direction.

"One of them might have a cross," Lyndon heard Johnny think out loud. "I could still take them...nah, not gonna risk it."

Johnny turned into a wolf and fled the scene.

Lyndon glanced up and saw Ladybird running toward them, .22 rifle in hand. "Oh my lord, are you all right?" She said, alarmed.

'I'm alright, don't nobody worry about me. I...got bit by a dog is all," the former president said, knowing they wouldn't believe the truth if he told them.

"That didn't look like any dog I've ever seen! He ran on two feet." Head of Security Mike Howard exclaimed as he ran up to the porch. Lyndon reasoned that he saw Johnny before the transformation. "Let me take that from you Mrs. Johnson." He eased the .22 from Ladybirds hands.

"It was a dog and I won't have any more discussion of this," the former president said, and let the security man move him back to his chair. "I'll be fine."

"You'll need a rabies shot," Ladybird said as she handed him a shot of scotch.

"I said, I'll be fine," Lyndon looked to his head of security and said, "Are you gonna get more security on this or what?"

"Yes, Mr. President," Howard looked around the dark night and radioed for more security to the ranch. "Well, I'm going to look through the house anyways," he said then turned to two of the secret service men. "You two stay on the porch with the President,"

"Yes sir, Mr. Howard," the taller one said.

"I'm going to get some bandages and antibiotics," Ladybird informed her husband then went back into the house.

"I'm alright, just a little tired. Let's go to bed." They tried to get the former president to go to a hospital but he refused, so they helicoptered a doctor to the ranch. The doctor bandaged his neck and said, "I want to see you first thing in the morning sir. I still say you should go to the hospital."

"I don't need no damn hospital! It's just a small bite!"

"Alright sir, but we have to find that dog and check for rabies too. Or else I have to prescribe you a sequence of rabies shots"

"Alright, alright, let's go to bed. We can do that in the morning. " The President retired to the bedroom with his wife.

The next day was January 22, 1973; the President refused to get the bite checked. "I'm the President, and I make the decisions around here," he said. "No one is looking at a little scratch on my neck."

Not that it would have done him much good. At 1:10pm a thin trickle of blood seeped out of his wound, he put another Band-Aid on it. At 3:50pm he called the switchboard;

"Get...Mike..." The former President gasped into the intercom.

The secret service scrambled to reach their employer bringing an oxygen unit.

But it was too late.

The former President was ashen gray which they mistook for the blue skin of a man who died of natural causes. Mike Howard arrived at 3:55pm and tried to do an external heart massage. But the President did not respond.

By 4:45pm Lyndon's body was in San Antonio, Texas where Col. George McGranahan pronounced him dead. An autopsy was ordered at Brooke Hospital. McGranahan prepped the autopsy room and returned to the morgue for the president's body. His assistant, Col. Hieger, accompanied him.

When they got back to the slab that held the former President, he was gone. They turned the morgue upside down, but the former president was nowhere to be found.

"What the hell…"

"Where did he go?" Hieger said.

"He couldn't have just got up and left," McGranahan stared at his assistant for a long minute. "Someone must have stolen him." He paused then finally said: "Listen, I'm not getting in trouble for this. We have a John Doe over there that's about the same age…"

"You can't be serious."

"Do you want to explain to the media and the government how the body of the President disappeared? Especially considering what happened to the President before him?"

"But what if his body shows up somewhere?"

"One problem at a time, we can say this was the body we were given. We did the autopsy, not the identification."

The two coroners quickly prepared the John Doe to make him look as much like the former President as they could. Luckily, he had been identified by Lady Bird before they brought him in. She would not have to look at the corpse again. Given the former president's desire for a closed casket funeral, McGranahan figured they were safe.

\*\*\*

As a boy, Gabriel Bryant was fascinated with Japanese culture, and dreamed of visiting the Buddhist temple at Shitennoji. When he moved to Japan in 1982 as an adult, he became a Buddhist. He

attended the temple of Shitennoji on a regular basis. But by 1987, that didn't help much

Sweat ran down his face into his collar as he looked over his financial statements. The money had been hemorrhaging from his corporation since his competitor opened for business a couple of years earlier. He didn't know this was the Monday that would go down in history as "Black Monday" October 19, 1987. All he knew was that he was getting slammed. The U.S. market had dropped over 22%. Closer to home the Hong Kong stocks had declined by over 45% that day, which hurt even more since he traded with the Chinese too.

In 1982 Osaka was the third largest city in Japan, and the focal point of a chain of industrial cities. During the day commuters helped Osaka's population swell to the point where it has almost as many people as Tokyo. It seemed to be the perfect place for Gabe to set up shop in his import/export business.

Back in 1982 the economy was recovering from a recession. The era of Reaganomics had begun in America. His import/export business looked like it would prosper for many years to come.

It looked good on paper anyway. In practice his business took one bad turn after another. During the first year of the business he made a small profit and each subsequent year seemed to see about the same profit as the one before. He wasn't happy with that small profit margin as he had greater ambitions for his company, but he lacked the savvy to make the gains he was looking for. He should have been happy that at least he was ahead of the game.

Then about two years ago, a competitor sucked the life out of Bryant enterprises and he didn't know how to fight back. Hank Nelson Industries had moved in and in a big way. Gabe lost about twenty percent of his business that year and almost forty percent the following year.

He ran his fingers through what was left of the thinning red hair on top of his head. Sweat dripped off his brow into his blue eyes. It stung, so he ran to the rest room and splashed his face with water to clear the burning sensation.

He looked at himself in the mirror. He was as gaunt as a prisoner of war. Gabe had been underweight all his life, but he had really been losing weight for three months because of worry and poor eating habits. Now he looked seriously malnourished. His 5'8" frame, once close to a healthy hundred and forty-five pounds, now carried a mere one hundred and fifteen pounds. He was only thirty-eight years old but the increasingly sleepless nights that he

spent worrying for his family caused him to age so quickly he looked ready for retirement.

His skin was wrinkled and puckered. His horn-rimmed glasses looked like they belonged to someone younger, maybe his son, if he'd had a son. Gabe looked down at his desk. His depression faded as he stared at the photograph.

"God, they are so beautiful," Gabe said as he picked up the picture of his wife and daughter that was sitting on his desk. He smiled as he thought about the former Satou Rina, now Rina Bryant, and the beautiful daughter they had together, Katherine.

Rina was petite, which is how Gabe liked his women, since he was small himself. He ran his fingers along the silky smooth black hair that flowed down to her waist in the photograph. Then his fingers lightly touched her pretty face and he caressed her slightly upturned nose then those same fingers slid along those very thin lips. He smiled as he thought of how uniquely beautiful her skin tone was. It was dark but different from other Asian women. Her mother was Japanese and her father had been, part African American, part Caucasian, giving her a unique skin tone all her own. Many mistook her for being Indian.

Gabe's mind wandered. He thought of how Rina didn't pay close attention to the business. If her husband provided for the family she seemed fine. He thought that she suspected something was wrong but didn't know how serious the problem was. Gabe thought of how lucky he was to have such a beautiful young wife. Rina was ten years younger than he was and at twenty-eight could turn many heads; she looked at least ten years younger than she really was.

And I look twenty years older, Gabe thought. His attitude the last few months affected their relationship. He withdrew every time she asked him about the business and barely spoke to her at all, outside of small talk and pleasantries. He knew she was turning solemn, smiling less and less.

He hadn't brought her flowers in nine months. When they first moved to Osaka Gabe was a hopeless romantic and brought her flowers every three months. He loved her with all his heart but couldn't motivate himself to do anything to show it. He couldn't help feeling that he was losing this beautiful wife.

Rina was used to the finer things in life and Gabe didn't know how much longer he could manipulate the funds in his business to make it seem like they were prosperous. He needed money and he needed it now. All Gabe wanted to do was provide for his family

and now he was facing bankruptcy. Well, honestly, it wasn't just about his family.

Gabe opened the top right hand desk drawer and pulled out the revolver that he kept there. He knew that if he couldn't live the way he wanted to, he wouldn't live at all. He loved his family, but he loved money more, which the good book says is the root of all evil.

He stared at the gun. He played with the safety. It was so tempting to cop out and just end everything the easy way, but he loved his family. "It has to look like an accident," he thought out loud. If he committed suicide, then Rina and Kate would get nothing from his life insurance policy.

He put the gun back in the top drawer then shut it.

The door buzzer rang. He had to let his secretary go about a month earlier so he answered it.

"Hello."

"Gabe, its Akio," his brother-in-law said into the intercom.

"It's open," Gabe responded as he hit the buzzer to let Akio in.

Gabe waited patiently as he knew Akio would be riding the elevator to his floor. After a few minutes, he heard the door knock.

"It's open," Gabe said again.

Akio entered the office and shook Gabe's hand. He admired his brother in laws attire, olive green suit without a wrinkle in sight. The perfect crease down the front of his pants showed that Akio cared about his appearance. His jet-black hair was slicked back without a one out of place; the perfect stereotype of a Yakuza gang member.

"How's it going?" Gabe asked.

"Really good; how's the business holding out?"

"It ain't. I don't think I'll survive this stock market. It's going to take years to recover. By then I'll be bankrupt."

"How will you provide for my sister?'

"I'll find a way, Akio. I won't let you down. I love Rina and Kate."

"I know you do. But they can't live like peasants." Akio's voice rose.

Gabe thought that this thin Japanese man had an imposing sound for a man of his tiny stature. "I know. I have a life insurance policy. One way or another they will survive."

"Stop talking like a fool. You will see your daughter graduate and then go to college."

"Lord knows I want to," Gabe sighed then put his head in his hands. "I just don't know how to make it happen any other way."

"I know a way."

Gabriel Bryant lifted his head and stared intensely into Akio's eyes for a long moment. "You don't mean that Yakuza gang that you're involved with?"

"They are honorable people. If you need money they can help."

"I don't know if I want to get involved in anything illegal."

"You don't seem to have much of a choice. I can set up a meeting with Ryosuke. As an American you can't join. But you will earn enough working for Inagawa-Kai to take care of my sister and niece."

"I don't know if I can do what they would expect me to do."

"It can't hurt just to talk to him. And your alternative is bleak."

"You're right about that," Gabe paused for another long minute as he tried to think. "Okay, let's set up a meeting, just to talk."

Gabe spent the rest of the day trying to figure out if he should talk to these bastards. He knew deep down that it was wrong. But he also knew that he wanted to be with his family and watch his daughter grow up. Since he couldn't really join the gang he figured, how bad can it really be? He'd always be on the outside.

He looked at the calendar on his desk. Tomorrow was Kate's birthday and he knew that he had to get her a present. His decision was made. On his way home, he stopped at a store and looked around until he found something appropriate for an eight-year-old girl. After an hour of shopping he picked up a Daruma doll and purchased it. He didn't have enough money but he would find it somehow. His credit card still had some funds available, so he used that. The only thing he could think about was the joy that he would see on his daughter's face.

He pulled out the credit card, paid for the present, wrapped it, and then went home.

"Daddy, Daddy," Gabe heard his daughter's voice and his heart leapt. He had a gift in his arms and he knew that she knew it was for her birthday.

"Be careful with that pumpkin." Gabe said.

"What is it?"

"Open it and find out."

Kate tore off the paper wrapping and held her present high, "It's a doll!"

"A Daruma doll."

"Oh, daddy he's beautiful."

"Just like my princess."

Kate ran up to her father and hugged him. Gabe saw a huge smile form on his daughters face and he knew that he wanted to watch his beautiful daughter grow up.

Rina came out from the kitchen and kissed her husband.

"You always had a knack for buying the right gift," She said and smiled.

"Akio came to visit me today," Gabe said, frowning.

The smile left Rina's face. She knew that there would only be one reason for her brother to visit her husband's office. "Are things that bad?" She asked.

He tried to smile but couldn't. He felt the blood drain from his face and knew his skin had gone pale. "We don't have much of a choice."

His wife turned her back and walked towards the kitchen. She stopped at the threshold and spoke without looking back at him. "You have to do what's best," was all she could say.

\*\*\*

If Villarias and Bela were human, they would have been freezing. The snow was coming down fierce and heavy, an unusual development that served to heighten the tension and bring a feeling of foreboding to this ominous temple service. It was Halloween, and the vampires had gathered.

It was exactly one thousand years to the day that they had gathered for this same purpose once again and it seemed that God, or the fates, or karma if you will, was doing everything to prevent this monstrous night from happening.

The vampires formed a line, entering the temple two by two, Noah's ark style.

Bela and Villarias brought up the rear.

Bela had only been a vampire for one day.

Before he turned he was approaching his seventieth birthday. His body was ravaged with cancer and the doctors did not expect him to live long. He was ready for the end. He turned the night before thanks to Villarias. Both were in a new brotherhood of Lilitu vampires that had sprung up in Israel.

Since he turned he felt no pain and his once aged, cancer ridden body, which had very little life left in it, was more powerful than it had been when he was twenty. He learned quickly to appreciate the gift that Villarias had given him.

"Hurry up Bela, we don't want to be late," Villarias said as he motioned with the thin spider like fingers attached to his hand. His beady little eyes narrowed, making them almost completely shut and his smile revealed rotten teeth and sharpened incisors.

Villarias was one of Lilith's bastard sons. She bit him shortly after he was born. He was the offspring of Lilith and a demon from hell and he looked it.

No matter how much blood he drank he would never look younger than sixty years old, yet he was one of the most powerful creatures on earth.

As he lowered his arm flakes of skin dropped, like eczema, to the ground. His oh so pale skin, which had never seen sunlight glistened in the torch light of the tomb as he made his way into the room then grabbed one of the robes hanging on the wall and put it on. He watched as Bela also grabbed a robe that hung on the wall.

Villarias thought back to when he witnessed his people taken into captivity by the Egyptians. He loathed everything that came out of that country, yet he knew that if tonight's ritual were to succeed, he would have to put aside his prejudices in time for the second ritual. He wasn't sure if he could do that. He never could in the past.

"Why are we at the temple tonight?" Bela asked.

"You're lucky. This is a special night," Villarias told his new disciple. "This ritual only happens once every thousand years."

"What are we going to do?"

"Tonight, is the night that we bring back Lilith."

"Who is Lilith?" Bela asked.

Villarias laughed out loud and said. "Lilith is the original Hebrew vampire. She is my biological mother and the spiritual mother of us all. She, not Eve, was the first woman."

"I never read about her in Methods class."

"And you won't either. Lilith refused to be subordinate to Adam. And, unlike Adam and Eve, she left the Garden of Eden on her own."

"Why would she do that?"

"She didn't play the game brother. She left to mate with demons. She held a grudge against those who would make her subservient. It was Lilith who gave Lucifer the idea to become a serpent and tempt her successor into eating the forbidden fruit. She was living by the Red Sea when God sent three angels to bring her back. When she refused to return, the angels destroyed her demon-possessed kids. They smote them down with fiery swords while they played in the field overlooking the sea."

"What did the angels do then?"

"Nothing after that, they just left." Villarias paused then added; "Many regarded her as insane. Because after the angels left, she went over to her children, who lay bleeding on the grass, necks cut from ear to ear, and she caught the blood flowing from their throats with her cupped hands as if she wanted to stop it, put it back in their bodies. Then she looked up at the departing angels, raised her bloody hands to her mouth, and drank."

"That's how we were formed?"

"Correct. She felt it, felt the power their blood held. If it weren't for Lilith most of us would be dead and none of us would be here."

Villarias and Bela looked around at all the paired figures moving towards the temple. Some seemed to be softly moaning – or was it humming? He couldn't tell. "What happens after tonight? Is it true what I heard that we will become even more powerful?"

"Phase one of our metamorphosis will be complete. There are still two more phases that must be completed. And then we will never have to fear sunlight again." Villarias smiled and nodded at his friend. Then he put his arm around Bela's shoulders and led him inside.

Bela and Villarias entered the temple. There were about twenty other vampires. They all gathered in a circle around the altar which was covered with a black tablecloth. The only light source in the room was given off by ten black candles which surrounded the altar.

A container of Ketoret incense burned a thin plume of smoke which gave off a musty smell. Beside that on the altar, a scalpel, a silver chalice, a bottle of red wine and a cat 'o' nine tails scourge

were set in a neat row. Behind the altar on the wall a black cape and robe hung. They almost appeared to be swaying in the dark shadows.

All the vampires were dressed in black robes. The high priest's robe had an owl on it; a symbol of Lilith. On the floor was a bucket of what vampires considered to be holy water, not the kind that would burn them, of course. This water soothed them. Both vampires took their assigned seats at the altar.

The high priest picked up the bucket, dunked his baton inside, and shook the water over the vampires so they were all sprayed with droplets. Villarias swiped a piece of gray chalk from the altar then bent down and drew a pentagram on the floor. Bela looked on in fascination.

"Lilith arise, we implore thee." The vampires chanted as they prepared for the ritual.

The high priestess, Palti, entered. She was nude.

Palti donned the black robe and cape.

The High Priestess disdain for every vampire in the room was etched in her face. None of them were worthy to participate in this ritual. She grabbed the cat 'o' nine tails scourge and cracked it, making an evil hissing noise as she did.

The vampires bowed down, Villarias and Bela could feel their fear, they didn't dare to look upon the face of the high priestess. They knelt before her as if in prayer.

Villarias and Bela buried their heads in their hands as Palti spoke:

"It is our will to invoke the egregore of Lilith." Her voice was deep and commanding as she called upon the spirit of the Demigod. Villarias and Bela felt fear rise in the room and realized that every vampire must have been trembling and writhing in terror of what was to come.

They chanted in response: "So that by her spirit we experience the power of sex and death and obtain her word of power."

Villarias raised his head and drew back as he watched the high priestess tear at her robe and skin. She was writhing in ecstasy and Villarias knew that she was feeling the presence of Lilith grow deep in her bosom. He had witnessed the transformation four times over the last four thousand years yet each time was more terrifying then the time before.

Something was missing. Then Villarias watched as a red mist formed in the room. That was it. He knew what to expect next as

he buried his head in his hands once again. Bella didn't move. His head was still in his hands.

"Thump...thump...thump," they heard her heart beat louder.

"I am the daughter of fortitude and ravished every hour from my youth. For behold, I am understanding, and science dwelleth in me; and the heavens oppress me. They covet and desire me with infinite appetite; for none that are earthly have embraced me, for I am shadowed with the circle of the stars, and covered with the morning clouds."

As she continued the incantation, the red smoky mist thickened and a deafening crack, almost like a thunder clap, sent vibrations throughout the room. Villarias and Bela gripped the arms of their chairs to steady themselves during the tremor. One of the priests was slowly banging on a gong.

The vampires moved to lie down on the floor; they made weird hissing noises and squirmed in fear.

Thump, thump, thump, they heard her heart beat faster. "My feet are swifter than the winds, and my hands are sweeter than the morning dew. My garments are from the beginning, and my dwelling place is in myself. The lion knoweth not where I walk; neither do the beasts of the field understand me. I am deflowered, yet a virgin; I sanctify and am not sanctified. Happy is he that embraceth me: for in the night season I am sweet, and in the day full of pleasure. My company is a harmony of many symbols, and my lips sweeter than health itself. I am a harlot for such as ravish me and a virgin with such as know me not."

Bela glanced upward. As the high priestess continued the incantation her features were changing. Her fair pink skin turned to an olive tone and her hair, which had been dirty blonde, darkened. Villarias squeezed his hands around his head, afraid to look up. He knew what was coming.

The vampires rose to their feet. Face down, bowing before her, rising and bowing, with their arms extended and palms face down. "Flesh she will eat. Blood she will drink." They chanted.

"AAYYEEAAWWWAYYYEE," The high priestess let out a blood curdling scream. THUMPTHUMPTHUMP THUMPTHUMPTHUMPTHUMP. Her heart pounded louder and faster than it ever had.

Villarias and Bela watched as she dropped the cat 'o' nine tails and lay prone on the altar in a trance.

She was breathing heavy.

The vampires turned their heads to watch the high priest walk up to the altar and take over the incantation. Palti could no longer continue speaking as her body was morphing.

"Dark is she, but brilliant! Black are her wings, black on black! Her lips are red as rose, kissing all the universe! She is Lilith, who leadeth forth the hordes of the abyss, and leadeth man to ruin...She is the irresistible fulfiller of all lust, seer of desire. First of all women was she - Lilith, not Eve was the first! Her hand brings forth the revolution of the will and true freedom of the mind! She is KI-SI-KIL-LIL-LA-KE, Queen of the magic circle! Look on her in lust and despair."

THUMPTHUMPTHUMP "HHHNNNHHHNNNHNN" They heard her heart racing and saw she was breathing heavier. "AARRGHGHGHH" she moaned as she thrashed about the altar. The smoky red mist now permeated the room.

The high priest filled the chalice with red wine. Then he picked up the scalpel and cut his left thumb; he anointed his forehead with the blood.

The vampires took turns cutting their left thumbs and anointing their foreheads with blood. Then the chalice was handed to each vampire and they touched the cup to the blood that was on their foreheads.

A pentagram appeared on the high priestess' forehead.

THUMPTHUMPTHUMPTHUMPTHUMPTHUMP. The high priestess heart was reaching the threshold of human endurance "HHNNHNNHHNNHHNNHHNN" her breathing was three times as fast as before. Each time a vampire passed the chalice to the next vampire her squirming increased to the point that she was digging her fingers into the altar. Blood seeped through her fingernails. Her head thrashed back and forth wildly. The red mist took on a human form and rested above her body. Villarias and Bela tried to look away but they were transfixed to the scene, like witnesses to an accident.

As the high priest drank the contents of the chalice Palti morphed further into the being that was Lilith. Her skin tone grew ashen gray. Her hair turned jet black. She rolled over and held up her hands. Blood gushed from her fingers as the nails grew in length. Her pupils went from blue to an ashen gray to match her skin. They dilated, huge as quarters. Her arms shook in pain and her hands stiffened; the fingers morphed into talons. The red mist enveloped her body.

THUMPTHUMPTHUMPTHUMPTHUMPTHUMP

THUMPTHUMPTHUMP.

They heard her heart thump irregularly and saw her breathing turn ragged.

"HHNNHHNNHHNNHHNNHHNNHHNHHNNHHNNH NNHHNNHHNN."

She sat up on the altar and screamed yet again as she arched her back in pain.

"AARRGGHHAARRGGHHAARRGGHHAARRGGHH ARRGGHH"

She knelt on the altar, contorting her back as her shoulder blades grew in length and the membrane on her back tore away. Her bones emerged through the skin and blood flowed freely through the open wounds.

They saw tears of water and blood flow from her eye sockets. Her body was slamming up and down on the floor as her shoulder blades changed shape and formed a pair of black leathery wings.

The high priestess passed out.

Silence.

The high priest finished the incantation. He was trembling and sweating.

"Black Moon, Lilith, sister darkest, whose hands form the hellish mire, at my weakest, at my strongest, molding me as clay from fire. Black Moon, Lilith, Mare of Night, you cast your litter to the ground, speak the Name and take to flight utter now the secret sound!"

"Ratsach sed nephesh," the creature hissed in her native tongue and then split into two beings; Lilith and the high priestess.

The high priestess dropped to the floor, dead.

Lilith laughed hard and loud. After a thousand year sleep she was free!

# 1

It was another freezing cold night in Boston, Massachusetts. The wind howled with a rage that said don't come out of the office, stay put, and brave me only if you dare!

I dared. I was out of Jack Daniels.

I got off duty from my part time security job and went to the office that I called home to discover the empty bottle. I panicked; life wasn't the same without my best friend.

I bundled up in my warmest undergarments, again. They were called Long Johns by some wiseacre a billion years ago and the name stayed. I put on a thick flannel shirt, ski pants, a heavy jacket and wrapped a scarf around my neck. I put the little flask in my coat pocket; it was empty but wouldn't be for long. I put extra warm gloves on my hands and went to the door.

God I hated cold weather.

I paused and looked back at my office, at the pathetic little room that had become my life since the separation. I should have picked up the papers and folders that were strewn about my desk, but I was in a hurry, it had been a whole four hours since I'd had my last drink. I couldn't stand how filthy the office was, but I didn't have the energy or the care to stop and clean it up. It was time to go; on the floor in front of the door were divorce papers that my wife wanted me to sign. They looked up and laughed, taunting me as I walked out. I popped a couple more vitamin C pills as I left. It was preventive maintenance against the elements.

I breathed a sigh and left the room, shutting the light switch on my way out. I double checked to make sure the door was locked. Someone might enter and steal the only thing I had of value; a thirteen-inch black and white television and the tiny DVD player that were on a TV stand beside my couch. I could make last call at O'Malley's if I hurried

O'Malley's was three blocks away, not far in the summer, but it seemed like ten miles in the bitter cold and snow that was Boston on this Halloween night.

I got to the bar and my mouth dropped. There were only three people sitting there but one of them was Frankie Langella.

Langella was a friend of my former partners. He worked out every day and looked it 6'1" of solid muscle. That fact made him arrogant and conceited. He wasn't attractive; he had a protruding forehead and a unibrow that would have made a good throw rug if he ever shaved it off. But the chiseled body made up for that with the women.

"Hey, Van Helsing, you kill Dracula yet?" He said with a stupid smirk that I wanted to wipe off his face.

"I do have a stake in my pocket." I shot back, not the best comeback but I wasn't in the mood for playful banter.

"How's Alex? I hear he's doing your wife lately."

I clenched my fist and wanted to end his pathetic little life in the worst way, but I just sat at the bar and ordered a J.D. and coke. Less coke, more J.D.

"Yeah, you remember Alex from high school; He was on top of you on the wrestling mat, now he's on top of your wife every night in your bed."

I didn't say anything, just stared into his eyes with a hatred that would have killed the fight in a lesser man, but Langella wasn't about to stop.

"What happened to you Vincent? You had it made. Top flight detective, gorgeous wife, kids, the whole nine yards, now look at you."

"Just lucky I guess." I handed the little flask to old man O'Malley. He obligingly filled it at no extra cost, as he always did to keep my business.

Langella moved in for the kill.

"I just got a promotion, they needed a new detective. I got your old job, Vincent."

That was more than I could take. I swung at the bastard as hard as I could and sucker punched him on the chin.

It didn't do me much good as he spun around and landed a blow which knocked me on my ass.

"Hey, hey," old man O'Malley yelled. "Saints be praised, you two take that shit somewhere else."

"Don't worry about it Sam," Langella said as he spit on me while I was prone on the floor. "I was just leaving."

Langella walked out the door. I got up. Even if I could have taken him, what would be the point? He was right anyway and that hurt worse than any punch ever would.

"Sorry Sam, can I get another?"

"Karl, Last Call was five minutes ago," He pointed at the clock. I got the distinct feeling that if I hadn't started a fight, a fight I was destined to lose, that he might have served me one more.

I sighed and walked out the door slowly, checking both ways to make sure Langella was gone.

I caught sight of my reflection in the window of an abandoned clothing store. I'd had my hair cut earlier that day and it was bad! Cowlicks sticking up like a Mohawk. I looked like the illegitimate brother of Johnny Rotten.

Between the bad haircut and the moron with a badge, I left O'Malley's angry enough to take on the world! I wasn't drunk, I was completely plastered.

When I got back to my office I passed out on the couch.

I don't know how long I was asleep before I felt the room shake and bolted upright. I took a quick look around but everything seemed normal so I settled back into the couch.

Then I felt the couch move again. This time the force was even more powerful. The glass on my door cracked, creating a jagged diagonal line through the sign that said "Paranormal Investigator". I shot straight up. My head was aching and my hands were shaking. The room shook more violently then before and the glass on my door shattered into tiny pieces and fell to the floor.

I jumped behind the couch. All I could think about was how unlikely it was to have an earthquake in Boston. I was trembling and had to work hard not to pee my pants. Then I heard a voice from the past. It was a voice that I couldn't possibly have heard since the creature that made it had died years ago, and by my own hand.

"Mr. Vincent."

"Who's there?" I said. I looked around for a weapon.

"Come now Mr. Vincent. I'm disappointed."

A stake, I thought. I need a stake. "I know that voice."

"You should know me. You killed me."

I hesitated, "Sebastian? Is that you?" I twisted and gazed along the walls. Nothing, am I going schizophrenic? How could I be taking to a dead man that I don't see? I wasn't that drunk, I shouldn't have been hearing voices.

"You finally recognize me, old friend."

"You are not my friend, bloodsucker," I said as I continued to look for the source of the voice. At first I thought I was having a bad dream but that voice It wasn't in my head, but from somewhere in the room. "Former bloodsucker now, incorporeal being thanks to you." He sounded angry.

"What are you saying? That you've become a ghost?"

"I am saying that I am the spirit of Sebastian Vasilis."

I peeked around the edge of the couch, but I couldn't see him. My eyes darted from one corner of the room to the next.

"And I haven't forgotten Maine. Have you forgotten Islands Falls? Four years ago?"

I peered around for him. Oh, I remembered Island Falls, Maine, where I thought I was rid of him for good. He was the most terrifying vampire that I had ever encountered and the hardest one to destroy. The Roman Catholic priest for the church in Island Falls, Father Don Chaney Jr., had contacted me about a vampire that was attacking his parishioners.

Chaney looked a little evil himself. At sixty-six he was deathly thin and pale. With some brown streaks in what was left of his gray hair. His nose stuck out sharply on his slim face as the skin under his high set cheek bones sunk in. His lips were sinewy and he looked malnourished.

It was Father Chaney's description of what he was dealing with that led me to believe we were looking for Sebastian Vasilis.

It was rumored that Sebastian was, in all actuality, Radu Cel Frumos, the brother of Vlad Tepes, the Impaler; Dracula. At the time, I only knew Sebastian by reputation. I knew that, due to his lineage, he was one of the strongest vampires that had ever lived. His kind never turned. They were born vampires. They had powers which, at that time, I could only imagine. I would find out later just how strong this bloodsucker was.

I had never faced a vampire of his magnitude in my life. When I had agreed to take this job, I had gotten passed out drunk the night before the five-hour ride to Island Falls. I was scared to death and thought that I might not make it back alive.

Father Chaney and I discovered that Sebastian was hiding in an old potato barn just outside of town. I went out at ten a.m. the next day to destroy the bloodsucker. You never want to go at night. That would give them the upper hand.

I used the crow bar from the trunk of my car to pry open the barn door as wide as I could. It had been boarded up so that no sunlight would get in. If I had been stronger I could have opened that door all the way and just let the sun do its job, but that barn was boarded up good.

The flashlight beam illuminated the coffin in the far corner of the building. I hadn't yet developed my greatest weapon: The sun stick. I crept up to the coffin. It was made from a dark, shiny wood. I lifted the lid off as slowly and silently as I could. I positioned the stake over the bloodsucker's heart.

When I raised the mallet, I saw that it was upside down.

"Shit." The word escaped my lips, even though I knew that I shouldn't make any noise.

I turned the stake over and looked at that hideous face. The bloodsucker opened his eyes. He hissed and bent forward to sit up.

Sweat gushed from my pores. My arms and legs trembled. I shut my eyes and slammed the mallet onto the stake as quick and hard as I could.

He fell back down.

I stood there for the longest moment. Finally, I opened one eye. The coffin was filled with dust. The stake in my hands shook. I opened the other eye.

"I did it!" I exclaimed with triumphant glee. "I killed Sebastian Vasilis."

"I don't think so," A voice came from the shadows.

When I heard that voice, the remaining blood drained out of my face.

I turned around, shaking all over. There he stood, walking forward out of the shadows. I was tempted to reach for the flask of Jack Daniels I had in my coat pocket. I wanted to run out into the sunlight. But I stood immobile.

I finally got my first look at the creature which had come back to haunt me. Before that night, I only knew Sebastian by reputation. In the 1950's Sebastian would have been called a 'greaser.' But his hair wasn't slick with brylcream; it had the distinct putrid aroma of dead follicles that hadn't been washed in six hundred years. Sebastian's face was long and his cheekbones high upon his thin face. The craggy lines that outlined his visage made his face appear even longer than it was. He looked like a gothic rock star, especially around the eyes. The dark pupils

seared into the soul of whomever he stared at. They had an intensity that struck fear in all his victims, including me.

"What the hell?" I shouted, petrified.

"That wasn't me imbecile," The bloodsucker said with an evil, contorted smile on his face.

I was so scared that I dropped the stake and mallet, my only salvation in that barn.

"What are you going to do?" Sebastian laughed. "Kill me with your bare hands?"

I stooped, but he was faster than me. Sebastian bent down and scooped up the mallet and stake. It was the first of many times that I would see that condescending look on his face.

"Who was that?" I asked as I looked at the coffin.

"One of the parishioners of that church that you vowed to protect, I turned him into a vampire yesterday," he said. "Quite an easy kill, I might add."

Sebastian handed me the mallet I had dropped. "Here," he said. Laughing, he positioned the stake over his heart. "The moment you've been waiting for Mr. Vincent. Go ahead. Drive it deep."

The smell of blood curled from his mouth. I trembled so hard that I couldn't lift the mallet.

"You've never killed one of us that wasn't in a coffin, have you, Mr. Vincent."

"N...no," I said. And it was true. I don't even know how I got the three coffin doors of the vampires I had killed before this one to open, my hands were so shaky. Most vampires laugh when they think of the fearless vampire killer Karl Vincent. How was I supposed to kill one of the most dangerous vampires that ever lived? He had taken out more vampire hunter wannabes then I had taken out vampires, Including Abraham Van Helsing.

"Just lift the mallet, Mr. Vincent, you have one free shot."

I stood face to face with this creature from hell. The stench of the creature's breath was unbearable. Like the decay of over six hundred years of rot. I tried to lift the mallet but my arm was trembling so hard it fell from my grip and clattered on to the floor. I dropped down to my knees.

"You're so pathetic."

Sebastian bared his fangs and made an evil hissing noise. He pushed the collar of my coat aside.

The gesture revealed the string of garlic around my neck. Sebastian jerked his head around and plugged his nose, gagging at the spice which could send him to hell. "This is only a temporary setback you know," he said angrily.

Then I finally found the nerve to reach into my jacket and pull out my gun. I noticed a bewildered look cross his face.

Sebastian laughed. "That won't hurt me,"

Overconfidence would defeat this bloodsucker. I aimed for the wall behind his head and fired. The bullet hole let in a thin sliver of sunlight which burnt Sebastian's arm.

"Ouch," He recoiled. "You can't shoot enough holes to kill me."

I wasn't listening to him. I was trying to steady my shooting hand as I would only get one more shot at this.

Sebastian noticed I was concentrating on a certain part of the ceiling behind him. He turned around and saw the big window I was aiming for. When he realized what I was doing he lunged for me.

I fired.

Bullseye.

The bullet hit the lock that I aimed for and the window fell open, letting in all that glorious sunlight. It was with this kill that my confidence started to build. The three, or four if you include the parishioner that I had just staked, that I killed had been young vampires, newly turned. Sebastian had been a vampire for over 600 years, and he wasn't turned into a vampire. His kind was born vampires. This was the most significant kill I had made since I became a vampire. Wait, did I say four? It's five if you count the first vampire I had ever killed. But that's another story for another time.

Now it was my turn to have a shit-eating grin on my face. I watched Sebastian scream in agony as he burned up before my very eyes.

I knew that I'd never see him again.

Except, now he had returned, I couldn't believe four years had passed and this parasite found a way to torment me again. As I looked around the couch, the outline of his unearthly shape formed and filled in as he materialized in front of me.

"Have you come back to haunt me?" I asked.

"You mortals are so vain. Why must everything be about you?"

"Well, why are you here then?"

"I'm here to warn you, Mr. Vincent. Forces of darkness are about to be unleashed upon this planet unlike any you have ever seen."

"Why would you warn me?" I didn't trust him for one second. "Why would you, who revel in the destruction of human beings, suddenly turn over a new leaf and try to warn me about forces that you are a part of? Shouldn't you be happy about something like this?"

"For me to find eternal rest I have to help you destroy these creatures that will come to life or to prevent their resurrection. One creature has already been resurrected; the Hebrew vampire Lilith."

"I'm not your man. Most of the vampires I've killed, other than you, were asleep."

"Yes, I must say it was quite embarrassing to elude death for so many years only to be destroyed by the likes of you."

I don't think he would have been satisfied with any vampire hunter as his killer. But he was right. I was the bottom of the barrel in the world of vampire hunters. I'm surprised that I haven't been killed or worse yet, turned, by one of the bloodsuckers.

"But you do have a special knack other in your field don't have," he continued.

"Forget it find another sucker."

"Mr. Vincent, you have to help. The world is depending on you."

"It ain't happening. You ain't even tangible. How do you plan on paying me?"

"If you don't help, I will haunt you for the rest of your miserable life, which won't be long if you refuse."

I had to think that one over. I didn't like this bastard. I sure didn't want him around. I wanted him gone that day. "What exactly do you expect me to do?"

"As I have said the vampire Lilith has already been resurrected. We have to go to Cairo to prevent the resurrection of the Egyptian Sekhmet."

"You expect the two of us to go against an army of Setite vampires?"

"There will be more than two of us, Mr. Vincent. If Sekhmet is resurrected, then she and Lilith will be involved in a ritual that will

unite all vampires. They will become more powerful than they are now."

"Another diabolical plot to destroy mankind," I said sarcastically.

"This is no laughing matter Mr. Vincent."

"Alright, alright what do we have to do?"

"Prevent the resurrection of Sekhmet."

"And if we fail?"

"Then there will only be one more chance," Sebastian's look and tone became serious. "Prevent the resurrection of the Hindu Kali. If all three are resurrected, they will form an evil female trinity that will be unstoppable. Vampires will become many times more powerful than they are now. Mr. Vincent, vampires will be able to come out in sunlight."

That shocked me; sunlight? The armies of Lilitu, Setite and Tantric vampires, moving around in the sunlight but how could I trust this bloodsucker?

"You said that we wouldn't be alone?" I asked him. I finally agreed to join him. I only agreed because I was tired. I just wanted him to leave and let me return to sleep. I would have agreed to dance naked on top of the empire state building at that moment. Just to get him to leave and get back into my bed.

"That's correct. We will have many warriors to aid us in our noble quest."

"Stop being so clichéd," I laughed, "that's my job."

# 2

I was driving down the interstate using directions Sebastian gave me to find our first warrior. The location baffled me. The address he gave me was not in one of the better parts of town. We were headed to the Village, in New York.

The area I was driving to was one that I expected to find vampires in, not one of the saviors of the universe. Should I trust him? Was this just an elaborate set-up? He might have been setting me up with one of his vampire friends as revenge for Island Falls.

I was on my guard. The sun was going down and steam rose from the streets to give the setting a more ominous tone. Then I heard a voice.

"Ah, that's one of the things that I never enjoyed as a breathing being; the setting of the sun."

"Shit, what the hell..." I yelled. I jammed on the brakes, squealing the tires and hitting the curb as I came to a complete stop. I looked over.

Sebastian materialized in the passenger seat of my 1996 blue Toyota Corolla.

"I don't think that's good for the car." Sebastian said.

"Would you please materialize before you speak from now on?" I said then paused to catch my breathe. "You just scared the shit out of me."

"I know. I can tell. Your nerves are on edge and your blood pressure's too high."

"It's the company that I keep." I said as I pulled off the curb and drove away. "Shouldn't we be seeking help at a military installation?"

"Do you really want to seek help from those who would view you as a laughing stock?"

"I don't want to seek help at all." I informed the former bloodsucker. "I just want to go home."

"The Setites have infiltrated your military with familiars. They run for political office, are involved in every aspect of American life."

I didn't know what a familiar was. What kind of vampire hunter doesn't know what a familiar is? But I didn't want to ask Sebastian, since I would have to put up with his smug attitude and condescending tone again. I would find out later. So, I told him, "Terrific." I thought vampires were a dangerous but rare species, maybe one vampire to every five thousand humans, now I find out they're prominent in everyday life.

"Don't you thirst for adventure, Mr. Vincent?"

"I got adventure coming out of my ass," I said. "Incidentally, how are we supposed to fund this little trip? I don't have enough for a ticket to Cairo."

"That's where we're going, Mr. Vincent. Our first warrior is independently wealthy. He will help us fund this expedition."

I came up to the address Sebastian gave me. It was a dive bar, the kind that looked like there were gunfights inside every night of the week; two on Saturdays. I double checked the address on the piece of paper I wrote it on. It was the right one.

"This is where we're going to find one of the saviors of the universe?" I asked.

"Never judge a book by its cover, Mr. Vincent. You should have learned by now. Remember, you're the only one that can see or hear me, so don't talk to me."

I pulled the vehicle off the road and into a parking spot. The bar reeked of urine and alcohol. The place was covered with graffiti. The sign over the building read 'Mars Bar Dive In.' a strange painting of a kangaroo with a jungle cat's head was on the wall; it stood out from the rest of the graffiti and seemed out of place.

We headed towards the entrance. A wino was passed out in front of the bar window. He was relieving himself in his pants. On the wall, next to the entrance the graffiti read 'After the Mars Bar, then what?' in bold letters. A beer bottle crashed through the window and I had to duck to avoid getting hit by it. The wino didn't seem to notice the shards of glass that came raining down upon him.

"Hey!" a voice that I assumed was the bartender's yelled. "Now I gotta clean that shit up."

Sitting beside the front door was a huge Neanderthal who reminded me of Mickey Rourke in "Sin City" He was chewing tobacco and reading a "Vampire Hunter" comic book. His B.O. blended in with the urine smell that the wino gave off.

As I approached the entrance to the building a man darted out and ran past me. He looked scared as hell. Another man ran out right behind him with a knife in his hand.

"I didn't know she was your girl," the first man screamed.

"Yeah, well you should find these things out before you sleep with someone," the man with the knife yelled as he continued chasing the first man down the road.

"I take it this isn't the place where everyone knows your name," I said to the doorman.

"No, this is the place where everyone knows your pain," the Neanderthal said, then smiled to reveal two missing front teeth. I looked at the tag that was stuck to his shirt. "Max Schreck," I read out loud and looked him in the eye. He squinted at me as if he were challenging me to do something about the name. He motioned me through the front door with his thumb then went back to reading his comic book. I walked inside, Sebastian floating behind me.

"Why are you so nervous?" Sebastian asked.

"Why? This place makes the 'Mos Eisley space port' look like 'Cheers.' I'm wondering if I'll make it out of here alive."

"We have friends in low places here."

"Easy for you not to be afraid: You're already dead."

I walked up to the bar and sat down. My hands were shaking as the bartender came up to me. I looked way up! He had a Ramones T-shirt covering his huge belly. The sleeves were cut off so he could show off his muscular build. I stared at the Tattoos covering his body. Some were fresh some were old.

"What'll it be?" the bar tender said with a deep growl as he took off his glasses and wiped them off with his T-shirt.

"Whiskey and Coke."

"Comin' up."

"J.D. none of that cheap shit."

"You shouldn't be drinking," Sebastian said.

"What? I'm in a bar. I gotta order a drink." Now the piece of crap was lecturing me on the evils of drinking. It was because of ghouls like him I started drinking in the first place.

The bartender set the drink down in front of me and looked around to see who I might be talking to. Then he gave me a weird look, like he was trying to figure out if I was crazy or not.

"I told you not to talk to me. You're the only one who can see or hear me." Sebastian scolded me like I was a child.

I opened my mouth and was about to give him a piece of my mind when I noticed the bartender staring at me. I passed a $5 bill across to him, smiled and lifted my glass like I was giving him a toast. I was about to take a drink when I noticed a huge bug of a variety that I'd never seen before crawling out of it. I set the glass down and excused myself to use the bathroom.

The entire room was covered with graffiti and the entrance to the restroom read 'Kilroy was here.' The bathroom stench was unbearable. I almost lost my lunch.

'Women don't let women harass each other!!! – Run' read more graffiti.

I unzipped my fly and lifted the toilet seat. I noticed 'Jesus Saves' written on the underside of the lid. I drained the main vein then I saw, hanging off of the rim, a used condom dripping onto the floor, apparently, a couple of the punks didn't want to get a room. I tried to move my foot out of the way to avoid some punk's mojo from dripping on it, but I was too late!

"Shit." I yelled as I grabbed a piece of toilet paper and wiped the goo off my shoe.

The sink and toilet were completely covered with filth; Cigarette ashes, feces, urine, semen, whatever dirt you would find in a gas station restroom, and then some. A roll of toilet paper was unraveled and draped all around the wall.

I left the room, shutting the door behind me, and then I let out the breath I had been holding since I had opened the door. I went back to the bar and sat down. I looked over to the corner of the room and saw a drinking contest between two men, one old, the other young.

"Go over to that old man who's drinking that young hooligan under the table." Sebastian said.

"An old man is going to help us take on Lilitu and Setite vampires?" He had to be joking.

"SHHH! Again, judge not per the appearance," Sebastian's tone was demeaning but then it always was.

"Alright I'll go over."

"Hey Mack," The bartender couldn't mind his own business. "Just who is it you keep talking to anyway?"

"The ghost of Barnabas Collins," I joked, as I threw down money for the tab and tip.

I sauntered over to the drinking contest area. There were about twenty people, mostly men. Half of them were cheering on the old man. The other half were cheering on the younger man, whose name, apparently, was Dick.

Dick appeared to be almost forty years old, still young but not for much longer.

"Hey, old man," Dick said to his opponent. "What makes you think you can drink me under the table?"

"Oh, I don't know," the old man responded, "the fact that you don't weigh as much as a fourteen-year-old girl and probably can't hold your liquor."

"Did you hear that, mates?" Dick said in a mock Australian accent as he turned to face his friends and ran his fingers through his purple Mohawk in a mocking gesture. "Randy Quaid here thinks he can hold more booze than I can."

I read his T-shirt which said Richard Hell and the Void Oids, an ode to a little-known band from the '80's. His shirt was also sleeveless and I could see needle marks visible around what was left of his veins which flowed like blue rivers up and down his pale, pathetically thin arms. His eyes fluttered as he turned back to face the old man. As he turned in his seat I could see part of his genitalia sticking out of a tear in his crotch. I turned away and frowned. That's not something I wanted to see.

He made Sid Vicious look like David Cassidy.

I studied the old man; the one Sebastian wanted me to recruit for this mission. He looked so out of place in this punk rock hangout. His shoulder length silver hair flowed straight down but curled upward before it hit his shoulders. He wore a red and black checkered flannel shirt with a gray coat pulled over it. He had on a pair of brown dress pants, neatly pressed.

The two men both lifted another drink to their lips. The old man was steady but Dick was getting a little green around the gills.

The old man downed his seventh drink, judging from the empty glasses turned upside down at the table, and then slammed that glass upside-down with the rest of them. The people in the crowd standing behind him cheered and laughed.

"Come on Roxburgh, Come on!" Someone in the crowd yelled to Dick. Roxburgh was apparently his last name.

Dick tried to down his seventh drink but it wasn't happening. Alcohol came out of the corner of his mouth and he leaned far back in his chair. Most of his drink spilled all over the front of his shirt, and then he slowly slumped out of his chair, down to the ground, where he passed out. His crew had a look of defeat on their faces as they handed money over to the old man and his supporters.

I studied the old man as he smiled at his victory. I had the strangest feeling that I knew him, even though I'd never met him before in my life. He looked familiar. I had flashbacks to the

1960's; Viet Nam, political assassinations, Woodstock; Hogan's Heroes, Green Acres, Star Trek. This man made me think of an era during which I had been no more than four years old.

"Call him Lyndon," Sebastian said.

"Excuse me, Lyndon?" I said to the old man.

He turned around with a shocked look on his face. Apparently, he hadn't gone by that name in years.

"Do I know you?" He asked.

"No, but a...a...an acquaintance...of mine sent me here to talk to you."

"About what?"

"I don't know where to begin. Is there some place that we can talk?"

He motioned me to follow him over to a booth at the other end of the bar. Another drinking contest with two other customers had begun.

"Congratulations on your victory."

"Oh, that. It was nothing. I do it every night," Lyndon said. "It's like I always say; a man can take a little bourbon without getting drunk. But if you hold his mouth open and pour in a quart he's going to get sick on it."

"That's funny."

"What?"

"That saying is from another Lyndon. Lyndon Johnson."

"Not another, son, I am Lyndon Johnson."

"No, I mean the thirty-sixth president of the United States."

"That's me."

"Come on," I laughed. "You can't be the President."

"But I am. What I don't understand is who the hell you are and how you know my first name, yet don't know who I am. How did you find me?"

"Tell him the truth," Sebastian said to me. "Don't make anything up."

I hesitated. Could Sebastian be serious? I sighed. What the hell, I'd followed him so far. I blurted out, "what I'm about to tell you might sound a little strange...but...well...I'm a, a vampire hunter."

Lyndon got real serious suddenly as he blurted out. "You're not here to kill me, are you?"

"What?"

"I never take another human life when I feed. Not even a Republican."

"No, sir, I didn't even know you had turned. I'm just as surprised as you are at you being here." I assured him.

"Then what the hell is it you want son?" He asked with a look of relief on his face.

"The Hebrew vampire Lilith has been resurrected. We must go to Cairo and prevent Sekhmet from being resurrected," I said. I couldn't believe how serious I sounded when those words came out of my mouth.

"Lilith huh?"

"You know her?"

"Only by reputation she's been hibernating for about a thousand years."

"So, you know that we have to prevent the Egyptian Sekhmet from being resurrected."

"We still have a few weeks before the ceremony."

"What ceremony?" I asked

"March 12, the day of Parmutit, the end of the world by Sekhmet," he said

"I knew that," I lied. I guess I should have known that. But I didn't really want to know much about them. The profession I found myself in was a living hell and the less I knew about these creatures the better. Just tell me how to destroy them. That's all I need to know. My skills as a detective had somewhat waned once I started drinking to excess. After I lost Barbara and the kids I just didn't care anymore. Of course, given the nature of our mission, that was kind of a necessary bit of information. I asked the question I had been dreading to ask. "I hate to be pushy...but I was told you would fund this little expedition because I...can't."

"Don't make much in your line?"

"In my old line of work, I made a lot." I said.

"What was that?"

"Detective."

"Hope you didn't work for that prick Hoover."

"But you seemed to like Hoover?"

"It's like this son; I'd rather have Hoover on the inside of the tent pissing out then on the outside pissing in."

"Oh." I said, not understanding. "By the way why are you so willing to help us destroy your own kind?"

"I hate what I am. Like I told you I ain't never killed another human being to feed. I don't want these creatures to take over. Hell, if I did drink fresh blood then I 'd look the way I did when I was thirty."

"Oh, well I'm glad you're with us not against us."

"What about you son, were you for me or against me?"

"Er, ah," I stammered, should I tell him the truth? Honesty is always the best policy. "I'm a Republican, I like Reagan. But I guess that was 'after' your time."

"Reagan? How did that fucking 'Bedtime for Bonzo' actor get to become President? I couldn't believe that I actually watched his acceptance speech!?" Lyndon bellowed.

"Sorry," was all I could say. I didn't realize Lyndon had such a strong animosity towards number forty. It was probably because Reagan had been a Democrat at one time.

He wrote something on a piece of paper. "Here's my number, son. Call me when your Republican ass is ready and we'll take on these bloodsuckers together."

"Thanks. I'll be in touch."

"Now finish that drink and get out of here before you find a size eleven Texas boot up your Republican ass."

I gulped down my Jack Daniels and coke then hurried out the door. I probably shouldn't have drunk it as I felt something funny buzzing around my throat. Sebastian floated out behind me.

I was glad to be out of that shit hole. It would be closed for health violations within a few weeks.

That was the prequel and first two chapters of the novel *Last Rites: The Return of Sebastian Vasilis*. If you'd like to read the entire novel it is available on line. Also through Kindle.

Top: Anja Akstin

Bottom: Karl in trouble before the effects are done.

Kevin Given is Karl Vincent

Lilith attacks Karl. Before the effects are added.

Producer/Director Jeffrey Crisp

Karl and Sebastian: The new Abbott and Costello.

The Mars bar, in New York Where Karl meets President Johnson (in the novel, anyway)

Finally made it!

## Notes:

(1) Andy Griffith Show page: https://en.wikipedia.org/wiki/The_Andy_Griffith_Show

(2) Don Knotts page: https://en.wikipedia.org/wiki/Don_Knotts

(3) IMDB http://www.imdb.com/title/tt0512583/

(4) Douglas Education Center: http://www.dec.edu/ts/

(5) Tom Savini: https://en.wikipedia.org/wiki/Tom_Savini

(6) Writer's Boot Camp http://www.writersbootcamp.com/

(7) The Black List: https://blcklst.com/

(8) Rob Reiner on the LBJ biopic: http://www.hollywoodreporter.com/news/woody-harrelson-play-lbj-political-802759

(9) Lilith https://en.wikipedia.org/wiki/Lilith

(10) Sekhmet https://en.wikipedia.org/wiki/Sekhmet

(11) Kali https://en.wikipedia.org/wiki/Kali

(12) Thor https://en.wikipedia.org/wiki/Thor

(13) President Lyndon Johnson https://en.wikipedia.org/wiki/Lyndon_B._Johnson

(14) http://bestsellerpublishing.org/next-best-seller/